Egypt

Caught in Time

Egypt

Caught in Time

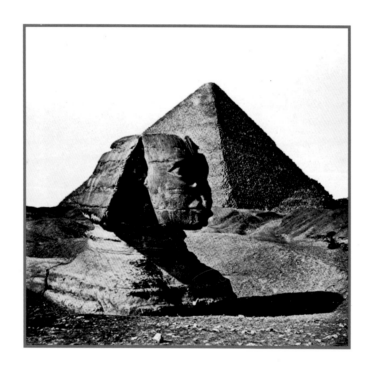

Colin Osman

Garnet
PUBLISHING

Egypt: Caught in Time

Published by
Garnet Publishing Limited,
8 Southern Court, South Street,
Reading RGI 4QS, UK

First edition 1997
Second revised edition 1999
ISBN 1 873938 95 0

British Library Cataloguing-in-Publication Data
A catalogue record for this book is available from the British Library

House editor: **Anna Watson**
Production: **Nick Holroyd**
Design: **David Rose**
Additional design: **Michael Hinks**
Reprographics: **Garnet Publishing Ltd.**
Map of Egypt on page vi drawn by Geoprojects (UK) Ltd., © 1997

Printed in the Lebanon

Previous page
1. A. Beato. Untitled, man sketching at the Sphinx. c. 1865.
The photographers were following in the steps of the long
tradition of artists working in the Near East. Many of their
photographs were purchased by artists, including well-known
orientalists and amateurs, as an alternative to sketching.

Contents

MAP OF EGYPT

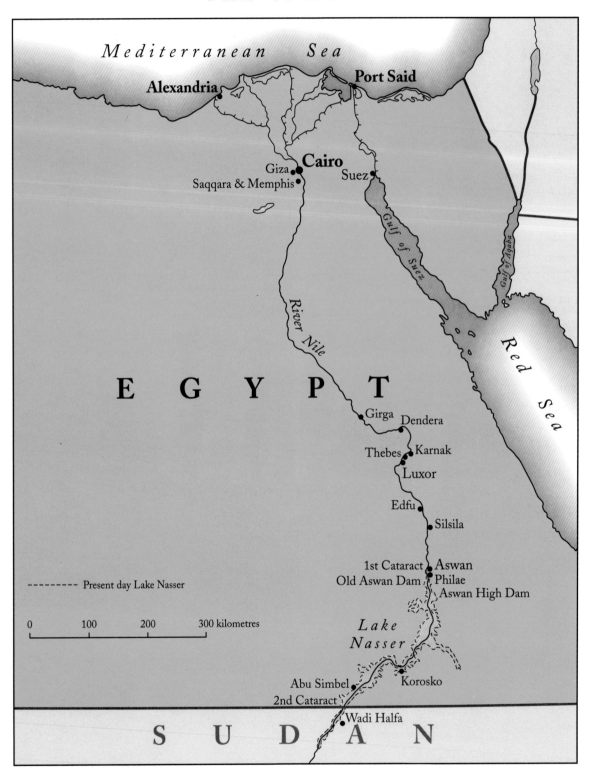

Preface

ONE OF THE MOST extraordinary stories of the nineteenth century was the way in which interest in Egypt and its antiquities grew steadily, until today Egypt is one of the most popular destinations for millions of tourists. The Romans and the Greeks had written about Egypt and the Nile; indeed the Macedonian conqueror gave his name to Alexandria and planned it as a Greek city. The story of Anthony and Cleopatra has been told and retold over the centuries. Roman accounts of the antiquities remained on the library shelves until Napoleon's time, when his expedition to Egypt in 1798 combined his attempt to found an empire in the east with a comprehensive documentation of his newly acquired colony.

Three years later history was to frustrate Napoleon, but although the Ottomans were the theoretical rulers, French culture dominated Egyptian life right up to and beyond the opening of the Suez Canal in 1869. Egypt's financial problems led to ever-increasing British control so that until the middle of this century, the real power lay with Britain, which had invaded the country in 1882. French remained the language of polite society. In law the Turkish Ottoman Empire retained suzerainty until 1914, but the reality was very different.

2. Bonfils. *Façade and Veranda of Shepheard's Hotel.* c. *1875.*
The design of the porch shows the rebuilding after the 1869 fire. The hotel was finally destroyed in the anti-British riots of 1952 and a car park was built on the site. A modern hotel with the same name was opened on the banks of the Nile in 1957.

The public interest in Egyptian antiquities manifested itself not only in the spread of orientalist paintings, particularly by French artists, but also in topographical scenes from artists of many nations – of which those of David Roberts are the best known. One result was that the Grand Tour of earlier centuries was now expanded to include the Holy Land, Mesopotamia and the Nile. Even before the Suez Canal, Egypt was fast becoming the favoured route to India and the Far East in preference to the long voyage round the Cape of

cannot be compared with these modern emulsions. Each sheet was individually coated by the photographer to his own formula, exposed in the camera with no aperture marks, and then developed by inspection, with the photographer again using his own formula.

Thus calotype exposures could be anything from one second to an incredible two minutes. Even this was faster than the daguerreotype, which could take as long as twenty minutes, thus requiring the well-known head clamp for portraits. Compared to the calotype, the wet collodion process allowed much faster exposures — often four to five seconds and on occasion even

as fast as $1/25$ second — so instantaneous photographs were possible, even though the problems of manipulating the wet plates were huge. The comparison of film sensitivity was made even more complicated by the fact that wet collodion plates, after development, usually needed a further chemical treatment to intensify the image. The quality of the best of them was superb and even today the wet process is still used in the printing industry because of the high definition obtainable. The later dry collodion process was far easier to operate but was about six times slower than the wet equivalent, so instantaneous photography again became more difficult. The views were not changed

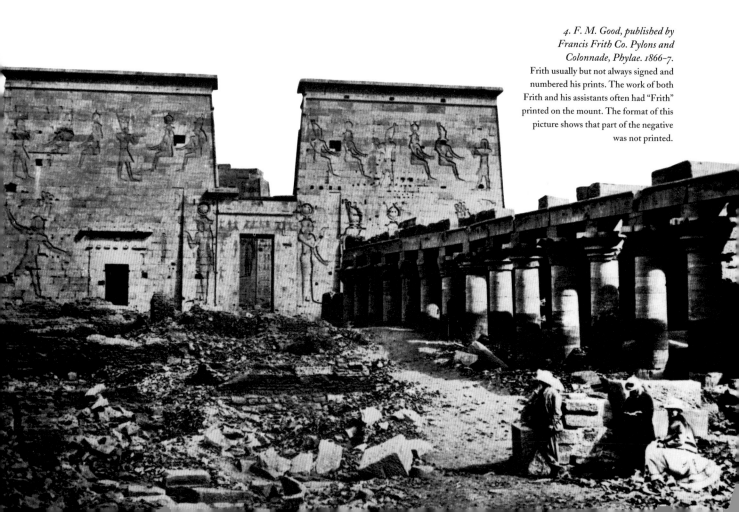

4. *F. M. Good, published by Francis Frith Co. Pylons and Colonnade, Phylae. 1866–7.* Frith usually but not always signed and numbered his prints. The work of both Frith and his assistants often had "Frith" printed on the mount. The format of this picture shows that part of the negative was not printed.

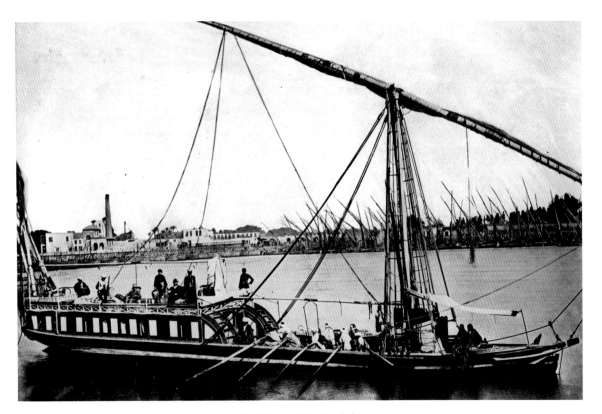

5. P. Sebah No. 41. Dahabiya. Before 1875.
This *dahabiya* looks particularly well-appointed. Rowers rest on their oars and there are Europeans
on the cabin deck. If it was Sebah's own boat he certainly travelled in style.

by the slower exposures − except that the leaves of the palm trees became blurry when the wind blew, and the patient donkeys lost their swishing tails − and the portraits remained the same − stilted and stationary. Francis Frith's well-known crocodile basking on the banks of the Nile was probably a stuffed one which was moved from location to location.

The positive material for making the prints, albumen-coated paper, had been machine-coated in factories, even in the 1860s when negatives were still hand-coated by the photographer. The improvement in negative material was paralleled by improvements in lens design. The 1886 Rapid Rectilinear lens was a great step forward for exposure times and absence of distortion. The old cameras had no shutters but the lens cap was removed while the photographer counted the seconds. Now shutters were needed for exposures measured in fractions of a second. The biggest change came in 1871 with the development of gelatino-bromide emulsions. These were factory-produced, had a shelf life of months, even years, and were more sensitive to light. Even if they were still slow by

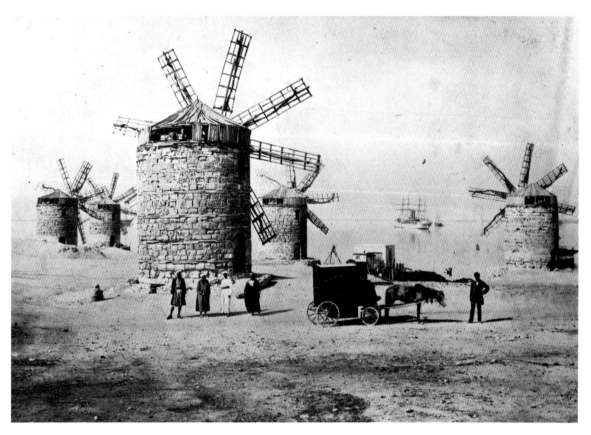

*6. Zangaki. Darkroom Van at Lake Mariut
(detail). c. 1880.*

The van with the unhappy horse appears in a number of
Zangaki photographs. Because of the limited colour
sensitivity of pre-panchromatic films the red portion of
the lettering does not register on the film but it can still be
read as "Zangaki Bros, Photographers". As their captions
were in French, the use of English on the van is curious.
The same figure, undoubtedly Zangaki, appears in other
photographs. There are very few views of Lake Mariut. It
was a depression with fresh water and much cultivation,
although twelve feet below sea level. During the
Napoleonic Wars the dykes were breached and sea water
rushed in, thus defeating the French. Lawrence Durrell
reckoned thousands of acres of agricultural land were lost.
The windmills in the picture are some of the very many
maintaining the new fresh water level. Photo courtesy of
the Prentcabinet, Leiden.

today's standards, they were at least measurable at
4–6 ASA, and in direct line with today's materials.
They were no longer developed by inspection but in
darkness by time and temperature, and the chemi-
cals were often pre-packed in factories. The
gelatino-bromide emulsions were exported from
factories in Britain, France and Germany and
perhaps this partly explains the rise of the photo-
graphers in Port Said during the 1870s. The
commercial market was to be dominated by two
of these, Hippolyte Arnoux, who had a floating
darkroom on the Suez Canal, and the Zangaki
Brothers, whose horse-drawn mobile darkroom can
be seen in many of his pictures.

The difference was also in the marketing of the pictures. The first centre of photography in the Levant was Constantinople, where, over the years, thirty photographic studios were centred in La Grande Rue de Pera, in a non-Turkish quarter of the city.[1] Of these Pascal Sebah and the Abdullah Frères set up Cairo branches on or near Ezbekieh Square, close to Shepheard's Hotel and in a correspondingly non-Egyptian quarter. As well as these, there were at least twelve other photographers based in Cairo, also competing for business. Unfortunately their sales methods are not recorded. British tourist albums are often the work of one photographer, so the possibility exists that the traveller walked into the shop to look at the sample volumes and then chose and ordered his prints. In Luxor, the memoirs of Wallis Budge tell us that Antonio Beato (brother of the better-known Felice) had a number of sample books which were put on the Nile steamers and that his wife ran the shop where the orders were packed.[2]

When Beato died, his wife offered these for sale, so that we know that he had 25 sample albums with two to three hundred pictures in each.[3] In Luxor we also know that a passing rival left photographs on the boats and returned later to collect the money, an impractical arrangement unless a member of the crew was involved. The rival to Beato was said to be a "Port Said photographer" who, apparently, hawked his prints from ship to ship. Both Murray and Baedeker did recommend photographers in their guide books, but in the 1880s and 1890s chance must have played a large part in deciding which photographer's work was purchased. Adding to the confusion was the fact that identical viewpoints were available from different photographers.

7. *Antonio Beato. Luxor. The Photographer's Studio.* c. *1865.*
The white building with the sign "Photographie" relates to Beato; there was no other permanent photographer at Luxor. As there are no Beato studio portraits extant this building must have been his house, his darkroom and sales outlet. Earlier photographs by J. B. Greene and Francis Frith suggest the house was built between 1853 and 1859. The native boat is probably a ferry.

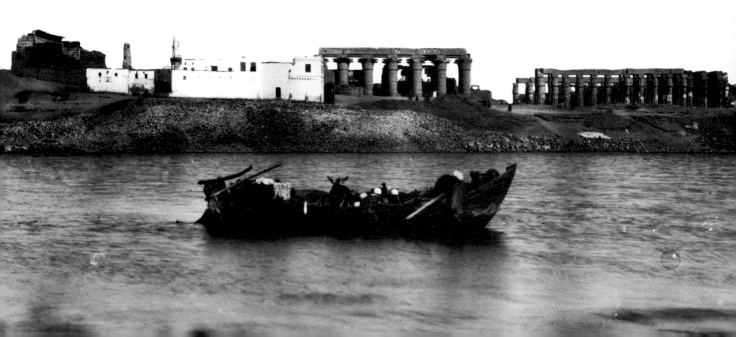

Many factors contributed to the final demise of photographic print sales at the end of the century: the decline of the big family album, the rise of the postcard, the advent of the snapshot and the snapshot album; but, perhaps more than anything else, the change of attitude as books and magazines could now reproduce photographic images with ease. The photograph was no longer an art object but a consumer expendable. The history of how that change came about in Egypt forms the basis of this book.

NOTES
1 Engin Cizgen, *Photography in the Ottoman Empire 1839-1919* (Istanbul, Haset Kitabevi A S, 1987).
2 Sir E. A. Wallis Budge, *By the Nile and Tigris* (London, John Murray, 1920).
3 Colin Osman, "Antonio Beato, Photographer of the Nile", *History of Photography Journal*, vol. 14 (April–June 1990).

8. Anon. The Pyramids.
The print is unsigned and the laconic title is on the mount. The camera seems to be a mammoth 16 x 20 inches dry-plate camera so the picture was taken during the 1880s. To the right of the camera are signs of emulsion damage on the negative probably due to the temperature. This size of camera was used at this time by Antonio Beato, Hammerschmidt and Lekegian.

9. P. Sebah. No. 39. Obélisque d'Heliopolis à Matarieh (detail). Before 1875.
There is also a larger print numbered no. 39 almost identical to this one. The white tent at the foot of the column was Sebah's professional darkroom, similar to that used by wet-plate amateurs.

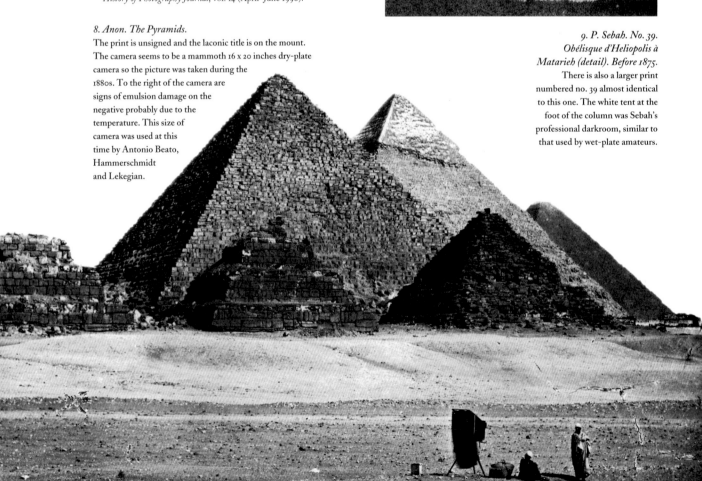

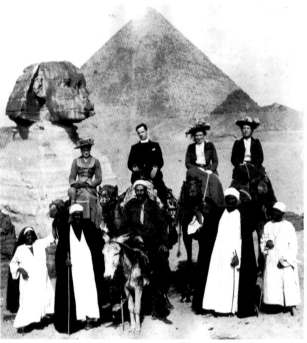

10. *Anon. Untitled.* c. *1885.*
The parson is F. B. Marsdin, the
compiler of the album. The party
included A. C. Marsdin, his brother, his
wife and two unidentified women. The
tour included Greece, Constantinople,
Jerusalem, Cairo and Rome – an
appropriate tour for a clergyman.

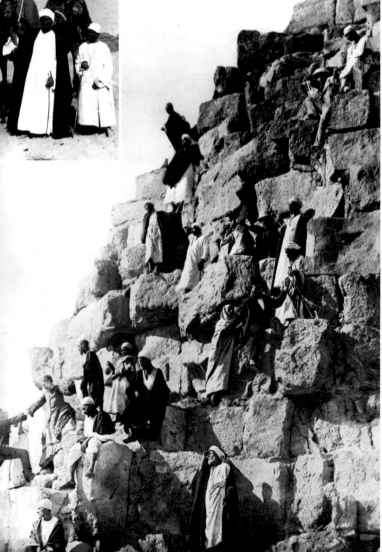

11. *Anon. (possibly Henri Béchard).*
Descending the Pyramid, 1880s.

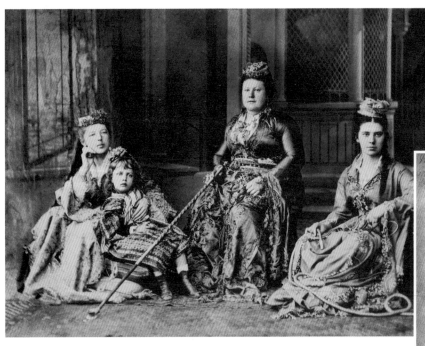

12. *Abdullah Frères. Handwritten on the front "To Father and Mother with Ellen's love"; on the back "Miss Long, Miss S. G. Callum, Mildred B. Seagu, Ellen Tattersall, taken April 1876".*

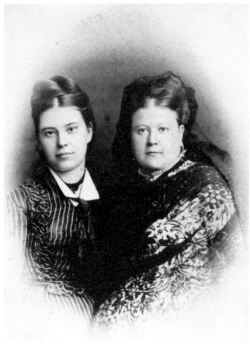

13. *P. Sebah. Handwritten on the back "For dear Mother with love Ellen", and "Taken August 75".* These come from an album with numerous portraits of Ellen Tattersall of Leeds.

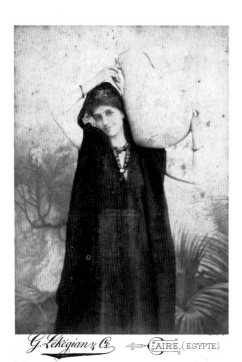

14. G. Lekegian and Co. Unknown European woman in native costume dated 6 April 1890. From the collection of Steve Eva Hon. MRPS.

15. H. Délié and E. Béchard. Unknown European "In the costume of a 'Pacha and son of a Pacha' (Egyptian)". From the collection of Steve Eva Hon. MRPS.

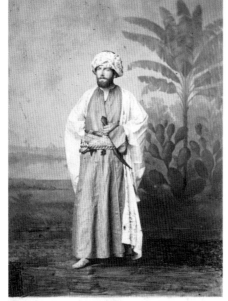

The Pioneer Amateur Years

THE VERY FIRST PHOTOGRAPHERS in Egypt were the daguerreotypists. The shiny image they produced on a metal plate included an immense amount of sharp detail. There were two main disadvantages. Firstly, the process was very slow so that even in good light an exposure was measured in minutes rather than seconds. Secondly, the image produced was a unique one, so that a non-photographic engraving had to be made for any reproduction of the image. It was this second disadvantage that was eventually to consign the daguerreotype process to the history books.

Very soon after Daguerre's discovery his process was purchased by the French government and became available to all. All, that is, except the British – who were expected to pay for a licence. Not surprisingly there were relatively few British daguerreotypists even in the portrait field, where the daguerreotype soon outrivalled the painted portrait miniature. The only British daguerreotypist in Egypt of note was the Scottish Dr George Skene Keith. His work was overwhelmed by the alternative process, the calotype or talbotype invented almost simultaneously by the Englishman William Fox Talbot.

The calotype process produced a negative with the obvious advantage that any number of positive images could be made fairly easily from it and all could be equally good. Decades later enlargements could be made from these negatives but in the early days of photography only contact prints were possible. This meant that to get large or small prints you had to choose a large or small camera. Most amateurs carried one camera only, usually one which produced prints about 9 x 7 inches. In later years professionals would carry several cameras to give different sizes of prints, from 16 x 20 inches to stereo cameras taking twin pictures each $3^1/_2$ inches square.

Before the invention of glass plates the calotype, with paper negatives, dominated photography. The sensitive emulsion was not just on the surface of the paper but actually embedded in its fibres. When the prints were made, the negative emulsion lay on the positive emulsion creating an attractive, soft image but without the sharpness of detail we expect today. The process could be improved by waxing the negatives either before or after exposure.[1] Remarkable results could be obtained. One of the amateurs in Egypt was Robert Murray, photographing about 1852. Ten years later he applied for membership of the Amateur Photographic Association, where he showed a selection of his earlier Egyptian prints.

By 1862 the wet collodion process had superseded the calotype, but the quality of Murray's prints caused the APA secretary to say that they "almost rival in sharpness and half-tone the finest collodion plates". Eventually the paper negative process was overtaken by the collodion and albumen processes, although for a while the calotype remained the first choice for travellers. The advantages of ease of preparation and manipulation far outweighed any possible lack of definition. Above all it was the simple factor of weight – paper versus glass.

Many of the amateurs took their pictures during the course of a tour of the Mediterranean. John Shaw Smith was journeying with his wife for about two years. The Reverend George Bridges was in the Mediterranean from 1846 until 1852. He produced at least 1,700 negatives over that period. The Frenchman Félix Teynard made his photographs in 1851 and 1852. Dr C. G. Wheelhouse accompanied a yachting party as a doctor from 1848 to 1850. The civil engineer, Robert Murray, was probably working in his spare time on the banks of the Nile for two to three years.[2] Later professionals, on shorter journeys, were helped by improving transport facilities which made the carriage of glass plates a distinct possibility. The leisurely amateurs needed to economize much more on the weight of their luggage. The diary of Mr and Mrs John Shaw Smith, which covers the period from 18 December 1850 to 6 September 1852, does not once mention the subject of photographic materials, which suggests the ease with which calotype requirements could be carried.[3]

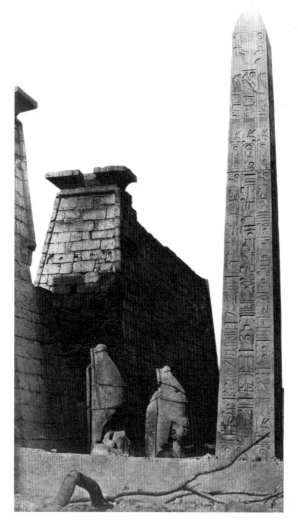

16. Robert Murray. No. 83.
The Obelisk and Propylon of Luxor (detail). c. 1852–3.
Bonomi writes, "In this view we have the companion Obelisk to that of the Place de la Concorde in Paris . . . The Hieroglyphic legend is most clearly rendered in the Photograph . . . Nearer to and on each side of the gate are the heads of two granite colossal statues of Rameses II who built the towers of the gate and adorned them with a record of his subjugation of an Asiatic nation whose stronghold or city was surrounded by water . . ."

Another advantage calotypes had over other processes was their comparative simplicity. This is demonstrated by Robert Murray, about whom very little was known until recently. He said in a talk to the Edinburgh Photographic Society in 1880, "I taught myself entirely from a shilling guide book (published by Messrs Horne and Thornthwaite)[4] while residing on the banks of the Nile far from professional assistance." On his return to England, J. Hogarth of Haymarket, London, decided to publish a portfolio of his prints. The Egyptologist Joseph Bonomi wrote extended captions which were printed in a booklet to accompany the photographs. Hogarth had published other portfolios before but nothing comparable in size to the Murray one. There were 163 "Photographic Views" priced at three shillings and sixpence each, or the complete series of photographs in three portfolios for £15. It was the largest portfolio ever published up till then. A long review in the influential magazine *The Athenaeum*, 1858, began: "All previous photographs of Egypt go down before the large and finely wrought views published by Robert Murray", and continued in the same enthusiastic vein.[5] Robert Murray's success cannot be underestimated as nothing on this scale had been seen before. Although Murray was to remain an amateur, he prepared the way for the professionals who were to follow. The fate of the other amateurs was disappointing and perhaps they themselves were equally disappointed. John Shaw Smith hardly took any photographs at all after his travels were over. The Reverend George Bridges failed to find a publisher and became a quiet country parson. Dr Wheelhouse gave his negatives to his patron Lord Lincoln and they were subsequently destroyed in a fire.

The calotype era was over.

NOTES
1 Colin Osman, "Richard Turner, Chafford Mills, Kent Papermaker", *Journal of the Society of Paper Historians*, no. 22 (April 1997).
2 Colin Osman, "Robert Murray of Edinburgh (1822–1893): The Discovery of Neglected Calotypes of Egypt", *The Photo-Researcher, Journal of the European Society for the History of Photography*, no. 6 (March 1997).
3 Manuscript diary of John Shaw Smith is unpublished and in the hands of his descendants.
4 The relevant catalogue of Horne and Thornthwaite was reproduced in facsimile as a supplement to *The PhotoHistorian*, quarterly journal of the RPS Historical Group, no. 113 (September 1996).
5 *The Athenaeum*, no. 1597 (5 June 1858).

Right
17. John Shaw Smith. The Hypostyle Hall of the Great Temple of Amun, Karnak.
Mrs John Shaw Smith, visiting in 1851, wrote, "Wednesday December 17th – Rose early and landed, to visit the Temple of Luxor, and what shall I say? Why, I was disappointed in it!! It was less grand than I expected, but it is hard to judge of it half buried as it is and all built within and without with those horrid mud hovels which stop up the view wherever you turn . . . There is the remains of a noble colonnade formed of a double row of majestic columns with lotus flowers on their capitals, and further on a square of columns having chambers in the centre, but such a confused mass altogether that I could not imagine the whole. We then embarked, breakfasted and as soon as we could collect our people started for Esnah, and then from the river the temple of Luxor did indeed look most imposing as we glided by."

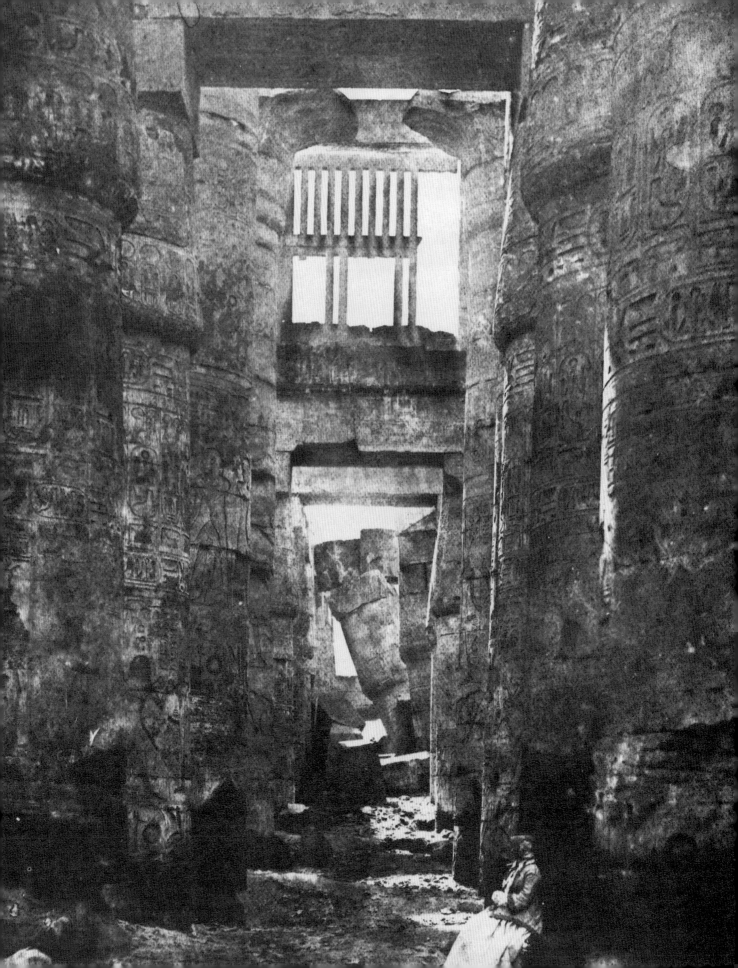

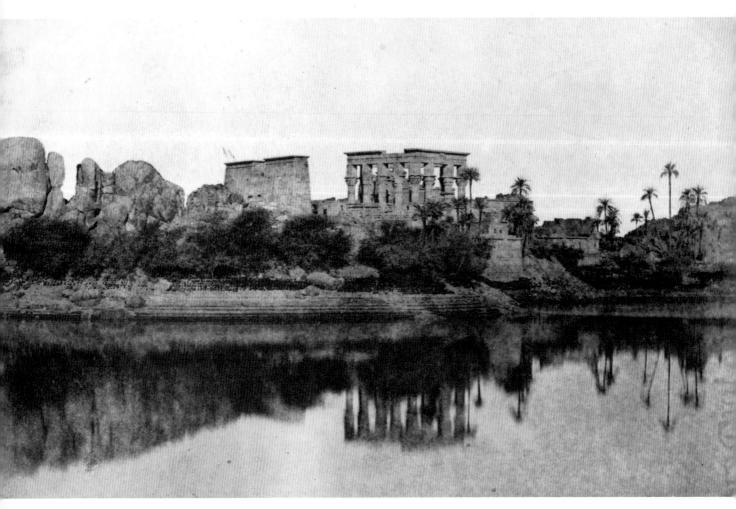

18. Robert Murray. No. 124.
View of the South End of the Island of Philae. c. 1852–3.
Down the right-hand side of the paper negative the watermark is just visible.
The complete watermark reads "Photographic R. Turner Chafford Mills".

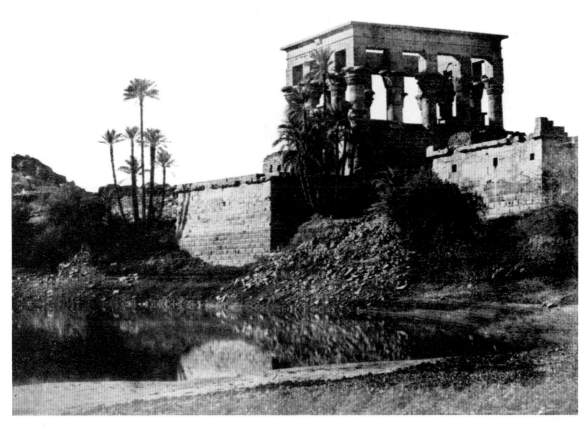

19. Robert Murray. No. 127.
Philae: View of an Unfinished Hypethral Roman Structure. c. *1852–3.*
The so-called Pharaoh's Bed "is remarkable for the height of the abaci above the capitals,
and also for the terrace wall, which is curved on the plan. Here the height to which the
inundation usually attains is marked by a whitish line on the face of the terrace-wall."
(Bonomi.) A similar view taken 4–5 years later is one of Frith's best known images.

20. Robert Murray. No. 105. Temple of the Time of the Ptolemies. c. 1852–3.
Joseph Bonomi wrote, "On the walls are represented Cleopatra and her son Caesarion . . .
In the corner to the right of the picture is a sheikh's tomb." This temple was at Ermont,
but is no longer standing.

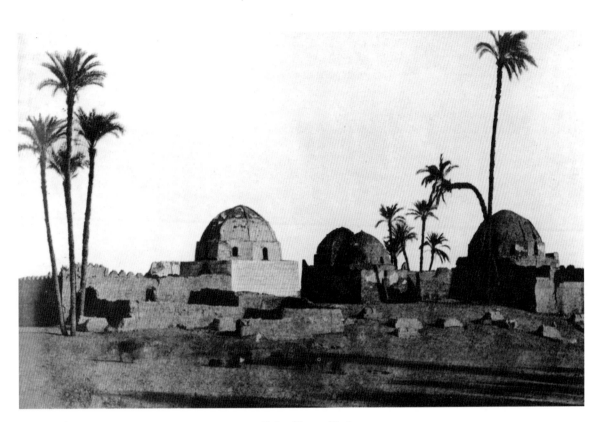

21. Robert Murray. No. 69.
Sheikhs' Tombs at Ekhmim, Upper Egypt. c. *1852–3.*
Bonomi says that this view represents a very common sight in Egypt. It is typical of the
civil engineer Murray that he should interest himself in the ordinary life of Egyptians.

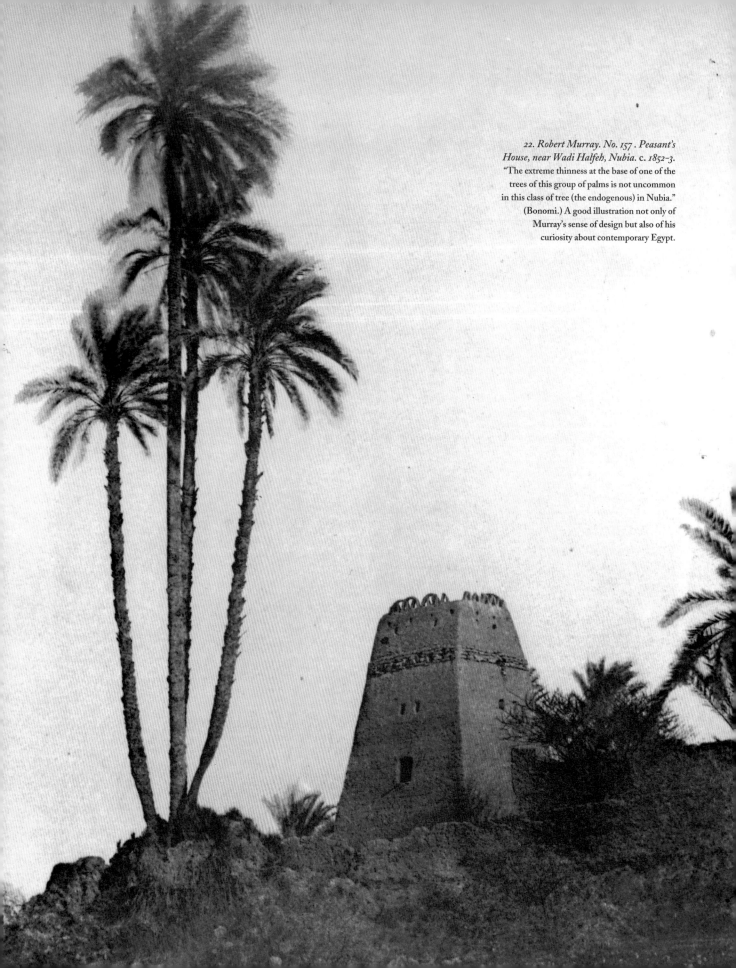

22. *Robert Murray. No. 157 . Peasant's House, near Wadi Halfeh, Nubia.* c. 1852–3. "The extreme thinness at the base of one of the trees of this group of palms is not uncommon in this class of tree (the endogenous) in Nubia." (Bonomi.) A good illustration not only of Murray's sense of design but also of his curiosity about contemporary Egypt.

23. Robert Murray. No. 61. c. 1852–3.
"Girjeh, the former capital of Upper Egypt, and inhabited principally by Christians. The Nile has made
great inroads on the banks here and threatens to wash away the whole town; the fate that befell Manfaloot,
a town formerly on the banks of the Nile." (Bonomi.) The crumbling bank on the right is witness to the erosion.
Considering that Girga is a largely Christian town, it may seem odd that there should be so many minarets in this view.

*24. Robert Murray. No. 67.
The Village of Ekhmim, Upper Egypt.
c. 1852–3.*
Bonomi writes, "Here is first seen the peculiar style of domestic architecture so general in Upper Egypt, in which the upper portion of the house is devoted to the rearing of pigeons. The upper parts of the walls are constructed of the earthen pots that are used also as the water-wheels, and near the corner is a mud-wall, the height of which has been increased by *djereit*, the sticks of the palm tree. Another incident which this picturesque view affords is the decorated door (lower right side), an intimation that the occupant of the house has performed the pilgrimage to Meccah."

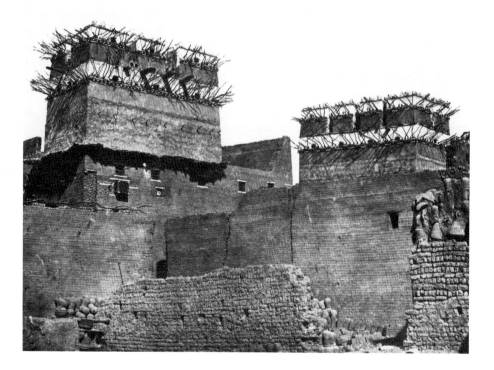

*25. John Shaw Smith.
Pigeon Houses,
Esne. 1851.*
Pigeons were an important source of food as well as manure for the peasants. Tourists could cause great offence by shooting them, assuming they were wild birds.

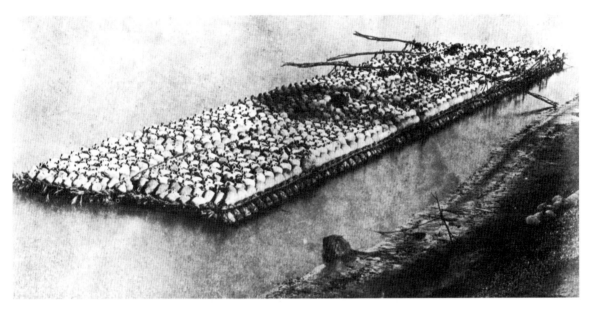

26. Robert Murray. No. 66. Raft of Water-Jars on the Nile. c. *1852–3.*
"These jars are made at Balas, a village on the west bank, whence they are called Balalees. They are ingeniously
formed into a raft, by being suspended and bound together with palm-sticks and grass-ropes, in which manner they
are safely floated to Cairo, a distance of several hundred miles." (Bonomi.)

*27. Robert Murray.
No. 122. The First
Cataract of the Nile.*
c. *1852–3.*
"The Granite rocks in the
foreground, and much of
the distant groups are
covered during the
inundations." (Bonomi.)

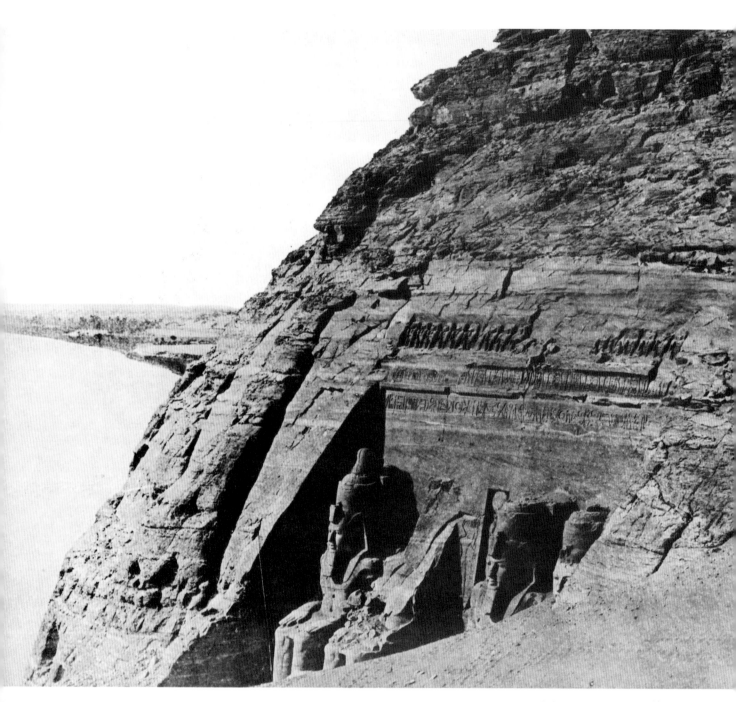

28. Robert Murray. No. 158. c. 1852–3.
"View of the Great Excavated Temple of Aboo Simbel, taken from the upper part of the rock. The series of depressions in the foreground are the impressions of footsteps in the avalanche of sand which separates this temple from its neighbour." (Bonomi.) The water is the Nile in flood, then nearer the temple than Lake Nasser is today, after the temple was raised to a site higher than in this photograph.

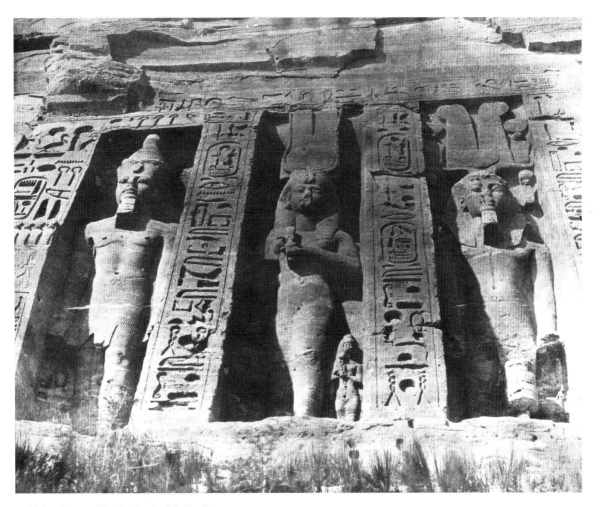

*29. Robert Murray. No. 163. Façade of the Smaller
Excavated Temple of Aboo Simbel. c. 1852–3.*
"The bank of the river is so narrow and steep, that it is
impossible to obtain a more perfect view of this temple.
The rock out of which these extraordinary temples are
excavated is a coarse irregular grit, of all materials the
least adapted for sculpture." (Bonomi.)

Right

31. John Shaw Smith. The Great Temple of Aboo Simbel.
Mrs John Shaw Smith's diary entry for Monday 29 December 1851 reads, "Reached Aboo Simbel early, and as soon as breakfast was over landed to see the Temple; visited the small one first . . . and from that was dragged up a hill of sand to the Grand Temple . . . On the facade of the Temple are four colossal statues of Rameses II seated on thrones, and nearly detached from the rock; in their countenances, vast as they are, is an expression of grand benevolent beauty which is most imposing and wonderful . . . John took four good views, one in particular of the colossal Rameses, is admirable."

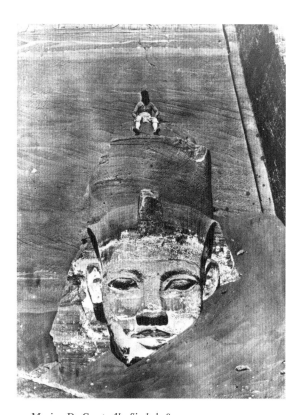

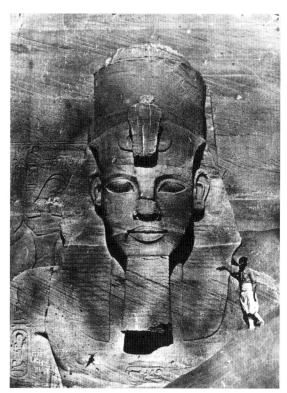

30. Maxime Du Camp. Abu Simbul. 1849.
These are two of a group of the first photographs taken of the heads, 65 feet high and 21 feet wide. Robert Hay made a plaster cast of the head, now in the British Museum. Years later the remnants of the plaster were darkened with coffee by Amelia Edwards. Du Camp used his Nubian servant, Hadji Ismael, to give scale to his pictures, keeping him still for the long exposures by claiming the camera lens was a gun-barrel.

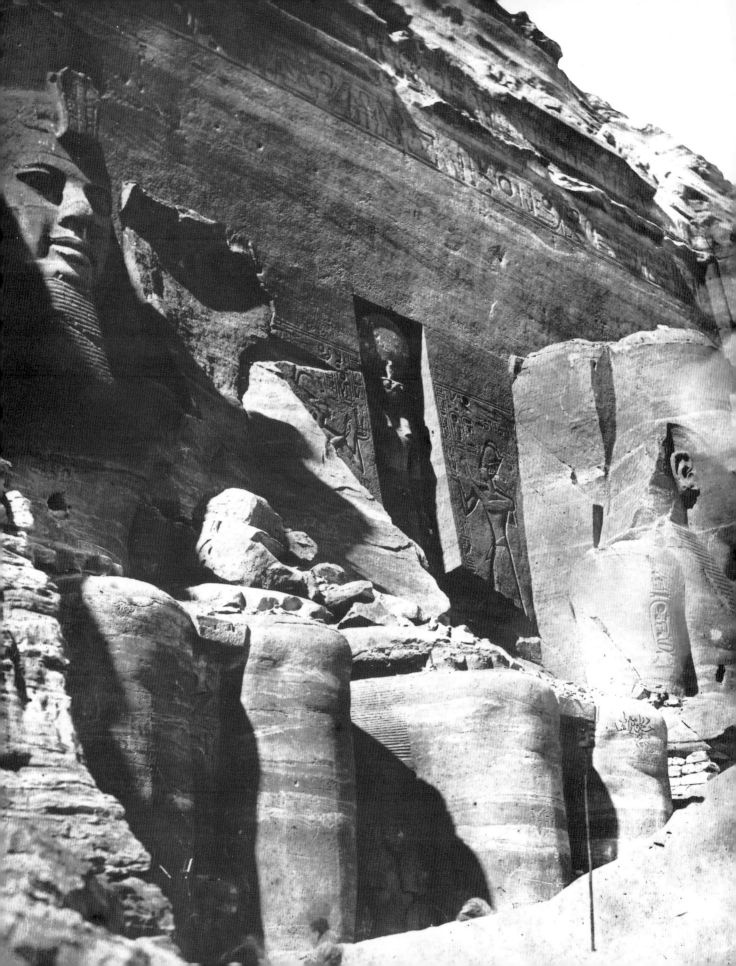

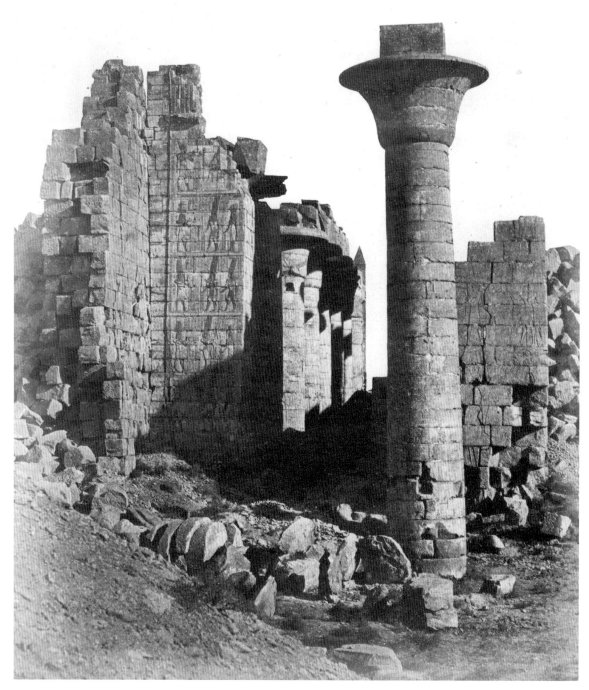

32. Robert Murray. No. 77. Karnak. c. 1852–3.
Bonomi writes "The only remaining column of twelve which stood in the middle of the open court of Shishak, Karnak. The shaft of the column exclusive of the capital and the base is 66 feet high . . . Behind and to the left is one jamb of the gate to the Hall of Columns . . . The entire wall on each side of the gate seems to have been thrown down by an earthquake."

33. Dr. C. G. Wheelhouse.
Hall of the Columns, Karnak.
In the foreground is the obelisk
of Tuthmosis III. Calotype of
1849–50. Later pictures show
how much of the central rubble
was removed.

34. Dr C. G. Wheelhouse.
Gateway in the North Wall
which enclosed the Sacred
Buildings, Karnak.
The jambes are divided in four
sections representing Ptolemy
Philometor (180 BCE) offering to the
various divinities of Egypt. An early,
1849–50, example of the calotype.

36. Heliosphot. No. 18. Entrance to the Granite Pyramid of Cheops. Possibly 1890.
A striking and rare photograph but nothing is known about the photographic company. This is the entrance opened, with gun-powder, by Colonel Howard-Vyse in 1837.

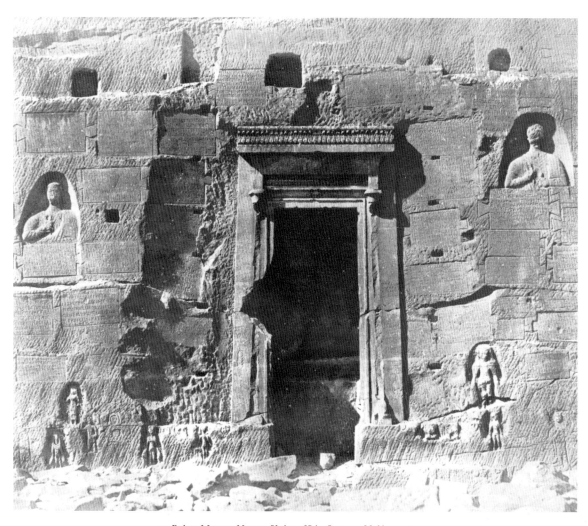

35. Robert Murray. No. 141. Shrine of Isis, Gertasse, Nubia. c. 1852–3.
Bonomi writes, "The Sandstone Quarry from whence the stone of almost all the temples in Nubia was taken. It is covered with numerous Greek votive tablets of the time of Antoninus Pius, M. Aurelius and Severus, cut in the rock. The door is a strange compound of Egyptian and Roman ornamentation."

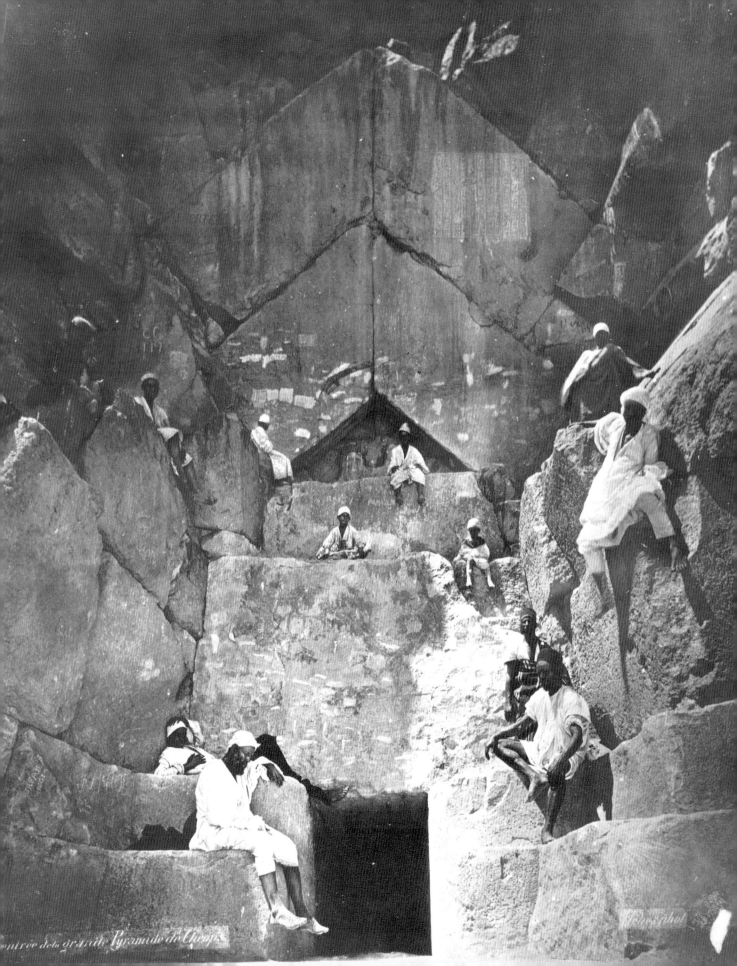

37. Robert Murray. No. 86. c. 1852–3.
"Near View of the Minaret of the Mosque of Abu el Hajaj built among the ruins of the Temple of Luxor. The pigeon-
house and the ruined dwelling; the ancient wall and its perfectly distinct hieroglyphics of the time of Rameses II, and still
nearer, the sleeping-places and utensils of the wretched hovels of the present inhabitants form a most interesting and
suggestive picture." (Bonomi.)

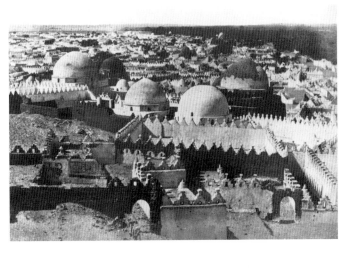

38. Robert Murray. No. 60. c. 1852–3.
"Mohammedan Cemetery of Essioot
(the ancient Lycopolis), the modern
Capital of Upper Egypt. This view of the
modern cemetery is taken from the place
of the ancient tombs." (Bonomi.)

*39. Robert Murray. No. 18. Mosque
of the Sultan Hassan taken from the
Al-Meidan. c. 1852–3.*
"The Mosque dates from about AD 1290,
is a fine specimen of masonry, and has
been entirely built from the casing-stones
of the Great Pyramid." (Bonomi.)

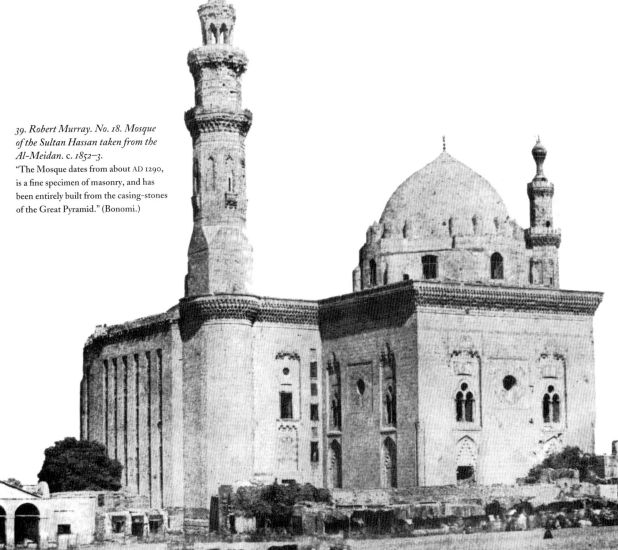

The First Professionals

THE VERY FIRST PHOTOGRAPHERS of Egypt had used the daguerreotype process. The amateurs had used the calotype paper negatives. The professionals who came a few years later used the wet collodion process. This gave superb definition and fine detail as well as an improved tonal range, but it was not an easy process to use. Francis Frith was the most professional of photographers, even building his own mobile darkroom so that it would be near the camera. He wrote in 1858:

> Know, then, that for the purpose of making large pictures (20"x 16"), I had constructed in London a wicker-work carriage on wheels, which was, in fact, both camera and developing room and occasionally *sleeping room* . . . This carriage of mine, then, being entirely overspread with a frame cover of white sailcloth to protect it from the sun, was a most conspicuous and mysterious-looking vehicle, and excited amongst the Egyptian populace a vast amount of ingenious speculation as to its uses. The idea . . . was that therein I transported from place to place – my – harem![1]

The harem wagon was not the only problem that Francis Frith faced.

> I prepared my pictures by candlelight in one of the interior chambers of the temple [of Gerf Hussayn, Nubia]. It was a most unpleasant apartment . . . The floor was covered to the depth of several inches with an impalpable, ill-flavoured dust, which rose in clouds as we moved; from the roof were suspended groups of fetid bats – the most offensively smelling creatures in existence.[2]

Francis Frith was not alone in working in atrocious conditions. The report of Felice Beato's celebrated 1886 talk in London states:

> On that (Soudan) expedition he had used gelatine plates, which he had frequently to develop at a temperature of 120 Fahr; another great difficulty was that of obtaining water; and a third difficulty was the visits paid, not by hundreds and thousands, but by millions of white flies, which looked in to see what was going on directly a light was struck in the developing tent. Directly it was dark they would all disappear again into the sand.[3]

This extract seems reliable even if the following reported claim to have made 25,000 prints in Egypt is suspect. Probably all photographers were given to exaggeration. Frith, the devout Quaker, claimed to have reached the Sixth Cataract near Khartoum but there are no known photographs above the Third. He can, however, be believed when he describes the white insects, as well as temperatures of 130 Fahrenheit:

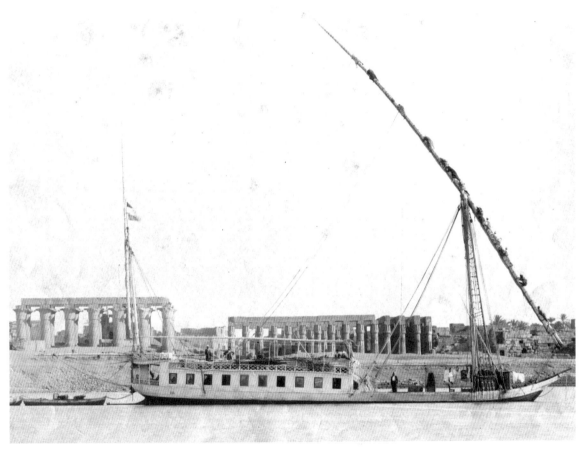

40. Antonio Beato. No. 102. Dahabiah at Luxor. c. 1880.
Photographers preferred the sailing *dahabiyas* for the freedom of movement. Crews
were large but not expensive. Two Europeans are on the cabin deck probably with their
dragoman. The crew, all twelve of them, are furling the sail on the boom, giving some
idea of the huge amount of sail carried.

Now in a smouldering little tent, with my collo-
dion fizzing – boiling up all over the glass the
instant that it touched – and, again, pushing my
way backwards, upon my hands and knees, into a
damp, slimy rock-tomb, to manipulate – it is
truly marvellous that the results should be pre-
sentable at all.[4]

The presentation and marketing of the prints
was quite complicated. Frith's prints were first
issued in 1858 as a subscription part-work in 25
monthly parts of three pictures at ten shillings a
time, which was a price equal to the weekly wage
of an agricultural worker at that time. The intro-
duction had an extra frontispiece, making a total
of 76 prints costing £12.50 over two years. Frith
says 2,000 prints were made from each negative.[5]
This would give the already wealthy Frith £25,000
– less the publisher's percentage and the costs of
the expeditions.

Expedition costs were not necessarily huge. In 1862 Lucie Duff Gordon successfully haggled to get the cost of her sailing boat, a *dahabiya*, down from £65 to £25 per month, which included the wages of a captain, a mate, eight men and a cabin boy.[6] Typical fares, including food, recorded by John Shaw Smith in 1851, are: Constantinople to Alexandria £10 per person, Alexandria to Cairo £3.[7] Frith paid £50 a month for a dragoman and a boat with full crew "who find for themselves".[8]

Almost immediately after the part-work was published, the prints were assembled into two volumes or portfolios. Volume One contained 37 prints and Volume Two 39 prints with a text by Frith interleaving each photograph. Each of the volumes contained a mixture of Egypt and the Holy Land. For example, of the 39 prints in Volume Two 26 are from Egypt. The two volumes with Frith's text were published in 1859, followed by a third volume in 1860. In this case the text was by "Mrs Poole and Reginald Stuart Poole".

The Pooles also wrote the text for the mammoth-size portfolio of 20 x 16 inches prints published by Mackenzie in 1860. It is an unsolved mystery why this portfolio contained only twenty prints. One would expect many more considering

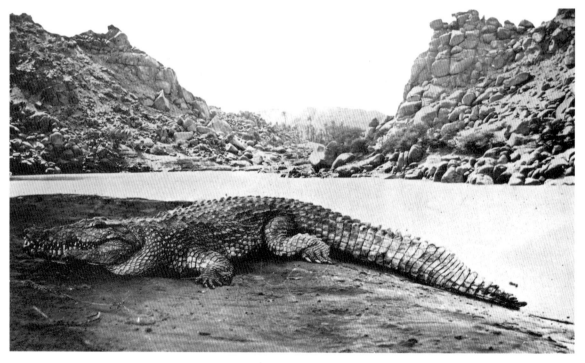

41. Francis Frith. No. E17. Crocodile on a Sandbank. 1857.
Frith wrote, "The Crocodile is almost as essentially one of the wonders of the 'Father of Rivers' as the temple ruins . . . he is one – almost the only living one – of the venerable 'institutions of ancient Egypt'." Unfortunately some doubt has been cast on Frith's crocodile as the same one appears in an identical pose at a different place and hence may be stuffed.

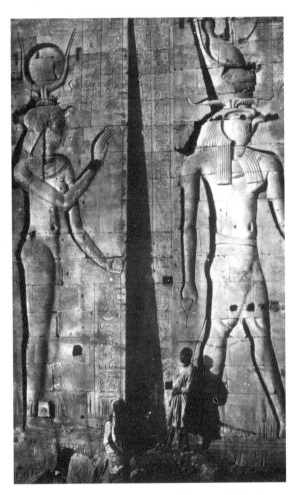

42. Francis Frith. Sculptures in the Grand Temple of Philae. 1857.
Nearly every photographer in Egypt included pictures of the carved wall
sculptures. Here the people give a sense of scale without looking to have
been posed.

the trouble of carting around such a huge camera.
As the negatives were developed on the spot it
cannot have been technical failure because any
dud exposures could have been retaken. The com-
mercial exploitation of his trips continued in 1862,
when 100 stereo pictures were jointly published as
a set by Smith Elder. Not surprisingly the well-
known firm of Negretti and Zambra were the first

to publish stereos of Egypt (1857) and the Holy
Land (1858), since Frith's companion on his first
trip was Francis Wenham,[9] the optical consultant
to Negretti and Zambra. The publishers to
Negretti and Zambra, James Virtue & Co., pro-
duced a 60-print set from the three volumes of
1858–60 and finally, in 1863, an enlarged set of four
volumes each with 37 prints. All of this must have
been a very handsome return on the investment of
three trips to Egypt. No wonder that, after he
married, Frith settled down but continued to pro-
duce thousands of views from all over England.

Frith's nearest rival was Francis Bedford, who
accompanied HRH The Prince of Wales on his
1862 tour of the East. He produced three portfo-
lios: Number One, Egypt – 48 photographs, 12
guineas; Number Two, The Holy Land and Syria –
76 photographs, 19 guineas; Number Three, Con-
stantinople, The Mediterranean and Athens – 48
photographs, 12 guineas. All three together cost 43
guineas for 172 pictures. The plates all had printed
captions but, when they were reproduced as a
book in 1867 with 48 reduced-size photographs,
W. M. Thompson wrote a descriptive text. These
were Bedford's major portfolios and they stimu-
lated a lot of interest. The only others available
were from France and were more expensive.

The only British price comparison that can be
made is with Robert Murray whose portfolio was
published almost a decade earlier. One of his
calotype prints cost three shillings and sixpence,
virtually the same as one of Frith's. As the number
of orders for Murray's prints increased, they
dropped in price – seven for one guinea, 50 in a

portfolio for 5 guineas (the Frith equivalent being £15). Murray's three Egyptian portfolios (155 photographs) cost £15, while the same number of Frith's, from all parts of the Near East, was nearly £50.

Unfortunately the world of Frith and Bedford was about to collapse. Their last publications were in 1863 and 1867. There were numerous spin-offs such as Frith's *Photo-Pictures from the Lands of the Bible illustrated by Scripture Words*, 1866, including Egypt as a Bible Land. Bedford's photographs were used to illustrate *The Stones of Palestine*, written by Mrs Mentor Nott and published in 1865. By 1869 the "art" portfolio virtually disappeared after the Suez Canal opened and Thomas Cook started his Middle East tours. Perhaps the last flowering was in 1869 when Frank Mason Good published his Holy Land pictures.[10]

Henceforth the pictures of Egypt were to be tourist ones produced in the Middle East for visitors to the Middle East.

NOTES

1 Francis Frith, *Egypt and Palestine Photographed and Described by Francis Frith* (2 vols., London, James Virtue & Co., 1858–60). The quotations come mainly from volume 2.
2 Ibid.
3 Colin Osman, "New Light on the Beato Brothers", *British Journal of Photography* (16 October 1987). The article reproduces the report of Felice Beato's talk published in the BJP 1886.
4 Frith, *Egypt and Palestine*.
5 Ibid.
6 Lucie Duff Gordon, *Letters from Egypt*, 3rd edn (London, Brimley Johnson, 1902). The letters were written 1862–9.
7 Manuscript diary of John Shaw Smith is unpublished and in the hands of his descendants.
8 Manuscript papers of Francis Frith compiled and edited by Claude Frith (grandson). Unpublished.
9 Francis Wenham, "Past and Present", *British Journal of Photography*, (12 August 1898).
10 Bertrand Lazard, "Frank Mason Good and his Middle East Photographs", *The PhotoHistorian*, no. 93 and Supplement no. 93 (1991).

44. *Francis Frith. No. E19. Wady Kardassy, Nubia. 1857.*
Frith wrote, "Here is a bonnie little ruin! It has no history, no lineage, no armorial bearings: – it
is like the pretty milk girl, whose face was her fortune . . . It seems as though the works had been
stopped and . . . I wonder if some benign governor will one day perfect any of these structures,
according to their original designs! Would there be any harm in such a proceeding?"

Left
43. *Francis Frith. The Approach to Philae. 1857.*
Frith wrote, "How well do I recollect that it was the moment of happy excitement when our party, after
being hauled up the cataract, reached the point from which my view is taken. In all sincerity, we were
deeply impressed by the combined beauty and interest of the scene."

45. Francis Frith. No. E30. Doum Palm and Ruined Mosque. 1857.
Frith wrote "The ruin is that of an old mosque, near the Island of Philae, and perhaps almost the
only vestige of religious observance in the whole of Nubia. It has the repute, also, of being one of
the oldest mosques in Egypt. The palm is a tolerably fine specimen of the many-stemmed or
branching variety, with an abundance of fan-shaped leaves."

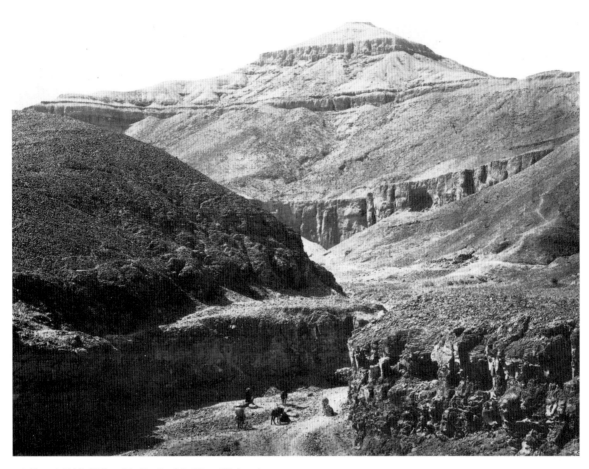

46. Francis Frith. Valley of the Tombs of the Kings, Thebes. 1857.
Frith wrote, "The entire course of this ravine presents a spectacle of desolate grandeur, which
is in the highest degree impressive, and prepares the mind fully to appreciate the effect of the
kingly sepulchres to which it leads."

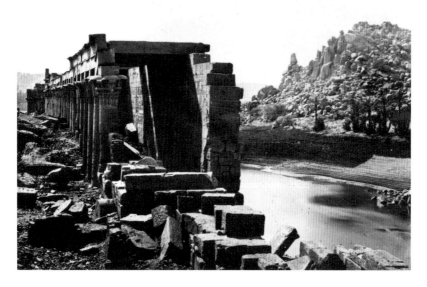

47. Francis Frith.
The Colonnade. 1857.
The west colonnade at Philae. The water
has blurred to a haze as a result of the
exceptionally long exposure needed to
get the depth of focus so that the whole
colonnade is sharp.

48. W. Hammerschmidt. The Great
Propylon of Edfu. c. *1880.*
One of the largest and most complete
temples of Egypt. The height of the
debris shows that at this time only just
over half the temple was visible. The
vertical niches were for flagpoles.

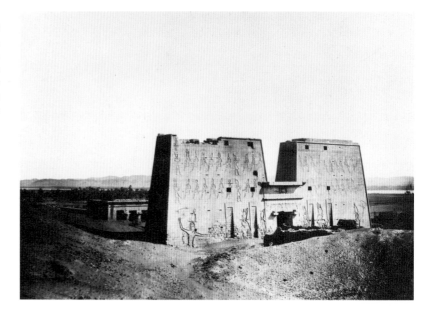

Right
49. Francis Frith. Pylon Gateway at Medinet-Haboo. 1857.
Frith wrote, "The Temples of Medinet-Haboo are situated on the
western bank of the Nile, and probably mark the position of the chief
portion of the city of Thebes which lay on that side of the river."

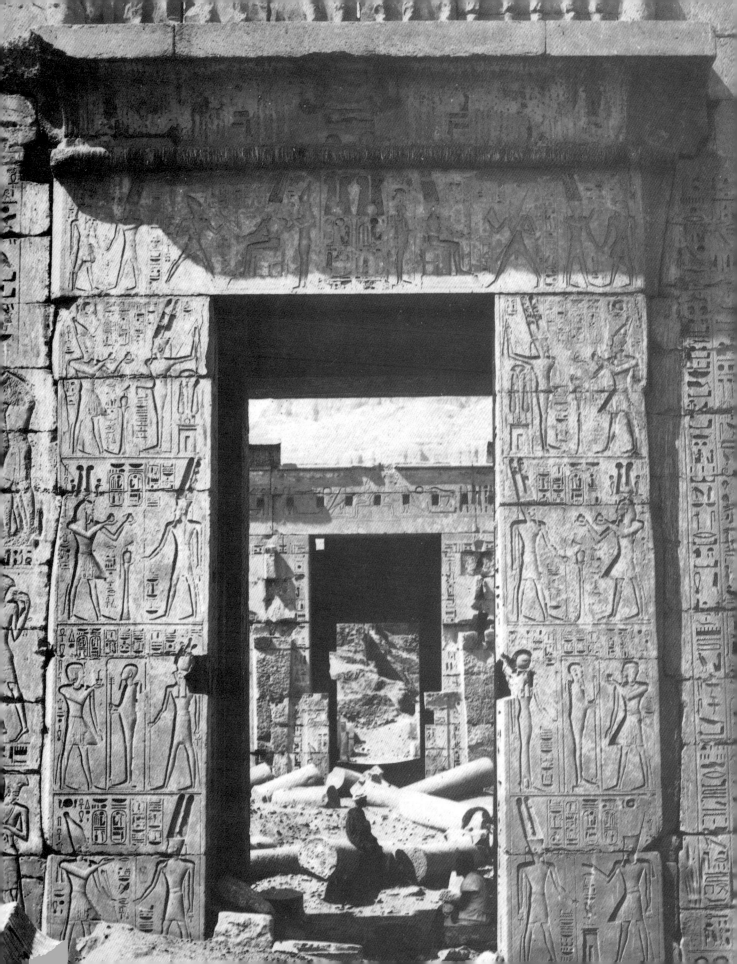

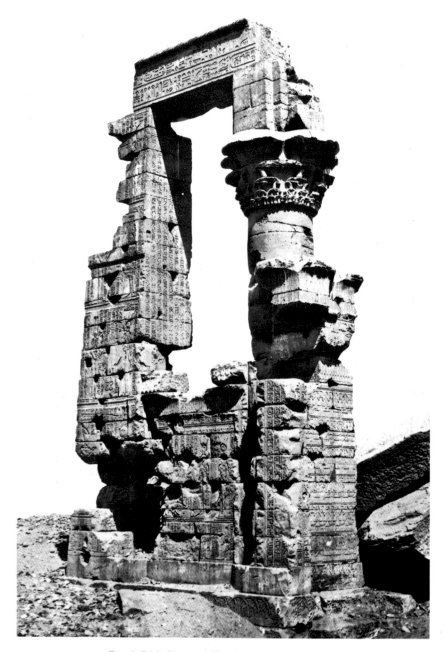

50. Francis Frith. Cleopatra's Temple at Erment near Thebes. 1857.
Frith wrote, "The photograph will give some idea of the abundance and beauty of
the sculpture, and also of the ruin into which the temple has fallen, and which is due
not so much to the ravages of time as to the vandalism of modern pachas and beys
who have broken up this precious relic of antiquity for the building of sugar
factories." Compare this picture with the centre of Robert Murray's photograph
(figure 20) taken roughly five years earlier.

51. *W. Hammerschmidt. The Ptolemaic entrance to the Temple of Khonsu at Karnak.* c. *1880.*
It is not always easy to relate pictures like this to the present-day appearance as huge amounts of rubble were removed and some temples were restored. This is not the northern gateway of Ptolemy III of today so the caption was not accurate originally. The traveller buying the print would have been unlikely to know or care, but it presents historians with a puzzle. The caption has been corrected here.

52. *Francis Bedford. No. 13. The Pyramids of Cheops and Chephren, Giza. 5 March 1862.*
Bedford wrote, "The generally current opinion that the Children of Israel were employed in constructing these stupendous works should be absolutely rejected, as they appear clearly to have been of Egyptian workmanship solely, without any trace of foreign aid."

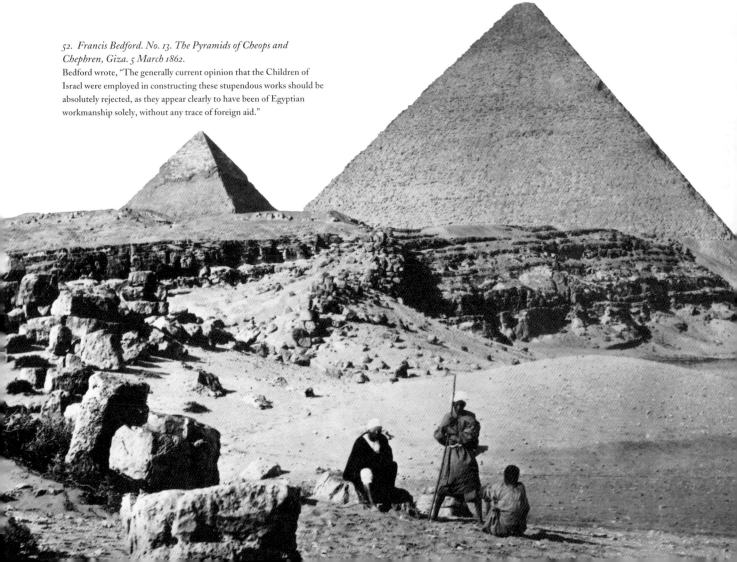

The Middle East Entrepreneurs

BEFORE 1869 PORT SAID did not exist except as a handful of huts. With the opening of the Suez Canal it became the major production centre for photographs, dominated by Middle Eastern residents, although none of them were of Egyptian origin. Two of the most important photographers were Hippolyte Arnoux, who from his name was presumably of French origin, and the Zangaki Brothers, possibly Cretan or Cypriot. This lack of information is unfortunately typical. Dates of birth and death are unknown, as are parents and countries of origin. They appear like actors on a stage with only their entrances and exits known.

Arnoux would have started in or about 1869 when Port Said became a port and a coaling station. One picture of Port Said is curiously dated 20 June 1885, but by 1894 it seems his pictures had passed into other hands. He is certainly the author of many photographs of the Suez Canal taken from his floating darkroom. From his Port Said studio, with its inappropriate French romantic backdrops, he produced a large number of portraits of local trades.[1]

Zangaki, as their name appears on countless prints, seem not to have used a studio very much but travelled widely with a horse-drawn darkroom. They were contemporaries of Arnoux and they disappear off the stage at about the same time, before the end of the century. Either they sold their negatives or had them pirated, because their prints surface in the 1890s with the name Peredis, presumably Greek, written on the overlay, and sometimes as Peredis and Georgiladakis, another Greek. This partnership seems to have been volatile, because some prints which were originally signed by both partners turn up with one or other of the names blocked out. Those signed by Georgiladakis alone have considerable merit, so perhaps he can be regarded as the last of the entrepreneurs. C. Zangaki appears after 1900 as a postcard publisher, using some of the old Zangaki Brothers studio pictures.

Photographic history can only be interpreted by seemingly unrelated events. The ships sailing to India and the Far East docked at Port Said for coaling. A small army of native coalmen carried bags of coal on to the ship to replenish the bunkers. It was a dirty, dusty job which took a whole day or more. The passengers avoided this operation by taking the train to Cairo, rejoining the ship, by train again, at Suez. They were sitting ducks for the print merchants. The name B. F. K. Rives appears as a blind stamp on some photographs. He may well have been a print depot for a number

of photographers. Others had their own studios, but portraiture was never an important part of the trade. Most native Egyptians neither wanted nor could afford their own portraits. The studios, however, carried a stock of native costumes in which European visitors could be photographed, a custom originating with the early orientalist painters. The studios were also sales depots.

In Cairo the studios were crowded around the Ezbekieh Square in the European quarter where Shepheard's and other hotels were situated. Some photographers whose main base was in Constantinople had branches here. Prominent among these were the Abdullah Frères, whose origin was Armenian, and Pascal Sebah, of French origin but born in the Middle East. Sebah published his catalogue in 1875 featuring Constantinople (141 views), Athens (138 views), Egypt and Nubia (117 views). As a footnote to the catalogue, Sebah mentions that he has a grand assortment of stereo views and a grand collection of "Costumes and Types of Egypt and Turkey". Significantly the catalogue is in French, the favoured language and culture of the time.[2] Even the Berlin photographer W. Hammerschmidt used French when he set up his studio, as did the Italian Antonio (or Antoine) Beato. The Cairo portrait studio of another Italian, Facchinelle, even described itself in French as "Photographie Italienne".

French influence began with Napoleon's invasion of Egypt in 1798 and, despite his army's forced withdrawal three years later, steadily grew, reaching its peak in 1869 with the building of the

Suez Canal, which the British opposed. The tide began to turn in 1875 when the Egyptian Viceroy (Khedive) Ismail Pasha fell into financial difficulties and sold his Suez Canal shares to Britain. In 1882 the nationalist revolt led by Colonel Ahmed Urabi against the Khedive and foreign control was quickly suppressed by British military intervention. The Khedive's authority was thus reinstated, and Turkey continued to be the suzerain power. But real power now rested with the British, whose

53. Antonio Beato. The Pylon at Edfu (detail) being photographed by Beato with his assistant (in a fez), probably A. Gaddis Senior. c. 1890.

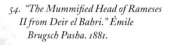

54. "The Mummified Head of Rameses II from Deir el Bahri." Émile Brugsch Pasha. 1881.

"rescue and retire" mission was to last for 72 years. In 1883-4 there were two uprisings in the Sudan against Anglo-Egyptian intervention, one by the Mahdi (Muhammad Ahmad) and the other by Osman Digna. At that time Korosko was not only an ancient staging post on the Nile but also the uppermost practical limit for navigation on the Nile; beyond it further progress had to be made overland by camel. History records how the British relief force failed to reach General Gordon at Khartoum. Korosko has now vanished under the waters of Lake Nasser. It was probably about this time that G. Lekegian and Co. were appointed the official "Photographers to the British Army of Occupation" and changed the writing on the backs of their cabinet cards from French to English.

Antonio Beato had worked with his brother Felice in Palestine under the supervision of James Robertson of Constantinople. When Felice went on to India, Antonio followed, but the climate was not good for his health. He went to Cairo but after a few months settled in the healthier climate of Luxor.[3] During the next forty years he photographed almost every archaeological site in Egypt and Nubia. So comprehensive was his coverage that on his death Gaston Maspero, the French Director of the Egyptian Antiquities Museum at Cairo, purchased his negatives because they recorded how the archaeological sites had appeared in earlier years.

It is only recently that the word conservation has been used in Egyptology. There had been tomb robbers in Egypt almost from the day the Pharaohs were buried. Even sanctioned expeditions were allowed to take away half of what they discovered. The British Consul, Henry Salt, saw nothing wrong in employing the adventurer Giovanni Belzoni to find objects that he would sell later to the British Museum. Museums in Europe and America were competing to possess Egyptian antiquities. The founder of Egyptology was Mariette Bey, who founded the Egyptian Antiquities Museum in 1858. This was the beginning of the end of indiscriminate looting. The Cairo School of Egyptology was founded by Heinrich Brugsch Pasha, and in 1875 he got wind of the discovery of large numbers of royal mummies in Deir el-Bahari, at the temple of Queen Hatshepsut. He hastily recovered them for the Museum, where they were memorably photographed by his brother Émile Pasha.

The idea of photography as an aid to conservation is not new. In the very early days of photography Fox Talbot had written on the use of photography to record hieroglyphics. Robert Murray used the talbotype process, and the 1858

review in *The Athenaeum* echoes the importance of securing images for posterity: "it is time we had a record of these losses (of ancient monuments) which are irreparable." In 1837, for example, the explorer and Egyptologist, Richard Howard-Vyse, blasted his way into the Great Pyramid with gunpowder.[4] A vociferous critic of failures in conservation is John Romer. In the 1993 book *The Rape of Tutankhamun*[5] he castigates the explorers for not being conservators. He quotes, disapprovingly, the current Keeper of Egyptian Antiquities at the British Museum, Dr Vivian Davies, as saying: "There is more than one way of conserving a site. In my view the best way is to document it properly, record it and publish it." Whatever the merits of this theory, the reality of documentation is Antonio Beato's negatives gathering dust and suffering damage in an understaffed museum. Despite all the talk about conservation the facts are that the stones of dismantled temples were used for new buildings – for example, a sugar factory – and those of the pyramids for a mosque.

Although conservation is considered important today, in the last century nobody gave it a second thought, and what we now call vandalism was then unremarkable. The graffiti at Abu Simbel and on a hundred other temples are proof enough. John Shaw Smith arrived at the Second Cataract on 31 December 1851 having taken "four good views" of Abu Simbel two days before. Mrs John Shaw Smith went walking with their companions, the Reverend and Mrs Giles, and watched them carve their names on the rocks. She herself was barely dissuaded from carrying off the rock on which the name Belzoni was carved.[6] Belzoni, who had written about his adventures in 1820, was a key figure in the early days of modern Egyptology. Many of his acquisitions are now in the British Museum and he is credited with rediscovering Abu Simbel; his carved name would have been a real trophy.

NOTES
1 Information about Arnoux and Zangaki is included in *Frederico Peliti, an Italian photographer in India at the time of Queen Victoria* (Manchester, Cornerhouse, 1994).
2 Colin Osman, "Pascal Sebah and Policarpe Joaillier", *The PhotoHistorian*, no. 115 and Supplement no. 115 (1977).
3 Colin Osman, "Antonio Beato, Photographer of the Nile", *History of Photography Journal*, vol. 14 (April–June 1990).
4 Leonard Cottrell, *The Mountains of Pharaoh* (London, Robert Hale, 1956).
5 John and Elizabeth Romer, *The Rape of Tutankhamun* (London, Michael O'Mara Books, 1993).
6 Manuscript diary of John Shaw Smith is unpublished and in the hands of his descendants.

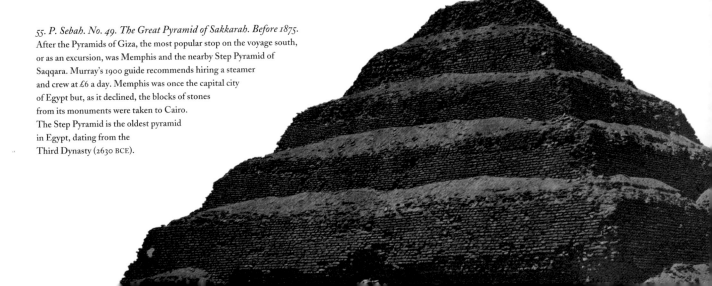

55. P. Sebah. No. 49. The Great Pyramid of Sakkarah. Before 1875.
After the Pyramids of Giza, the most popular stop on the voyage south, or as an excursion, was Memphis and the nearby Step Pyramid of Saqqara. Murray's 1900 guide recommends hiring a steamer and crew at £6 a day. Memphis was once the capital city of Egypt but, as it declined, the blocks of stones from its monuments were taken to Cairo. The Step Pyramid is the oldest pyramid in Egypt, dating from the Third Dynasty (2630 BCE).

56. Antonio Beato. Native Village at Edfu. c. *1875.*
The pylons seen far left are the only indication that this is an historical site. Otherwise it is just a village
with seven pigeon houses supplying the food. Perhaps because of his customers, Antonio Beato is often
regarded as a journeyman photographer, but here he is indulging himself by photographing the long
sweep of the shadows of the palm trees as the sun rises.

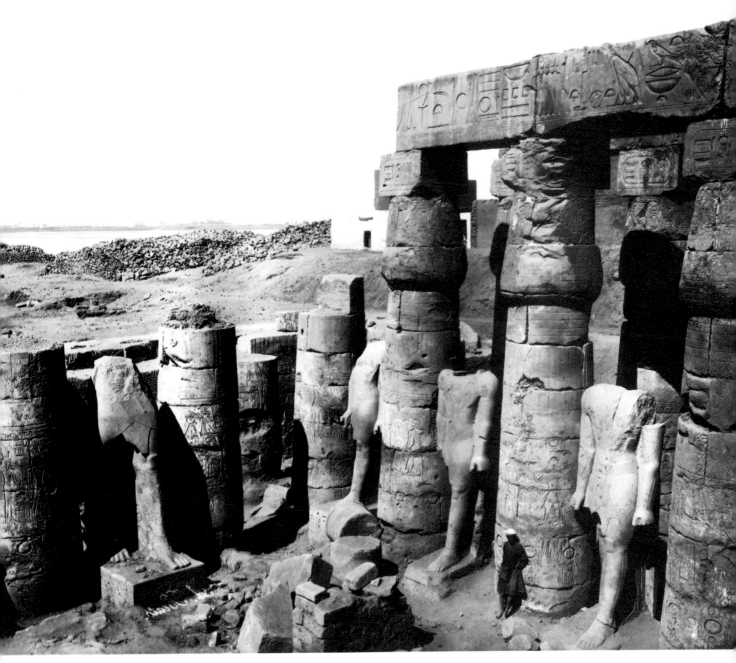

57. Antonio Beato. View of the first court at Luxor Temple. c. *1886.*
In the course of research on Antonio Beato I examined all the negatives available at the
Museum. They were all uncaptioned and some (as this) "signed" by his rubber stamp on the back
of the negative and thus his name is reversed. The negatives from which these modern prints
were made may not necessarily have been Beato's regular stock in trade. The negative for this
print is held in the Cairo Museum.

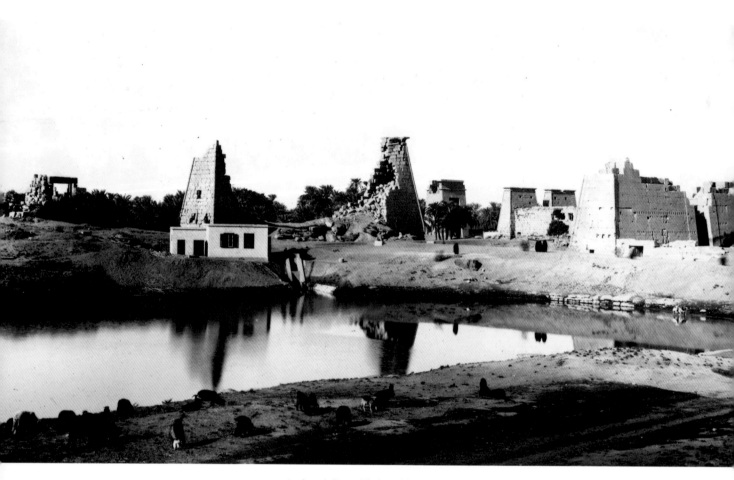

58. Antonio Beato. The Sacred Lake at Karnak. c. *1875.*
A photograph by Bonfils (no. 138) is taken from almost exactly the same point of view
showing the stone blocks where, here, the goats are grazing and without the new white
hut in front of the left-hand remnants of a pylon.

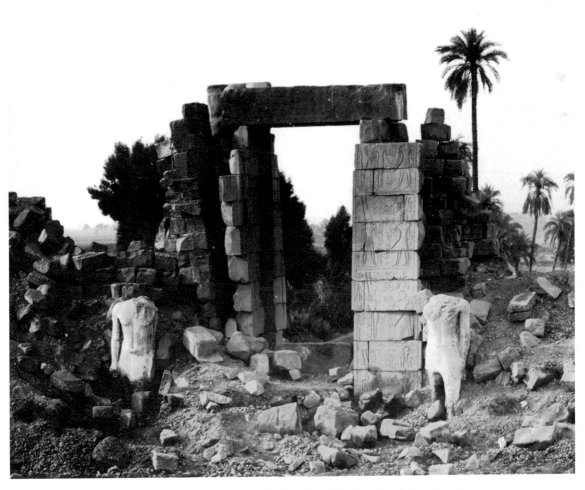

59. Antonio Beato. The Tenth Pylon or Southern Gate of the Great Temple, Karnak. c. 1870s.
After the vastness of the main temple with its giant columns this remnant of a gate and surrounding
wall has a particular beauty.

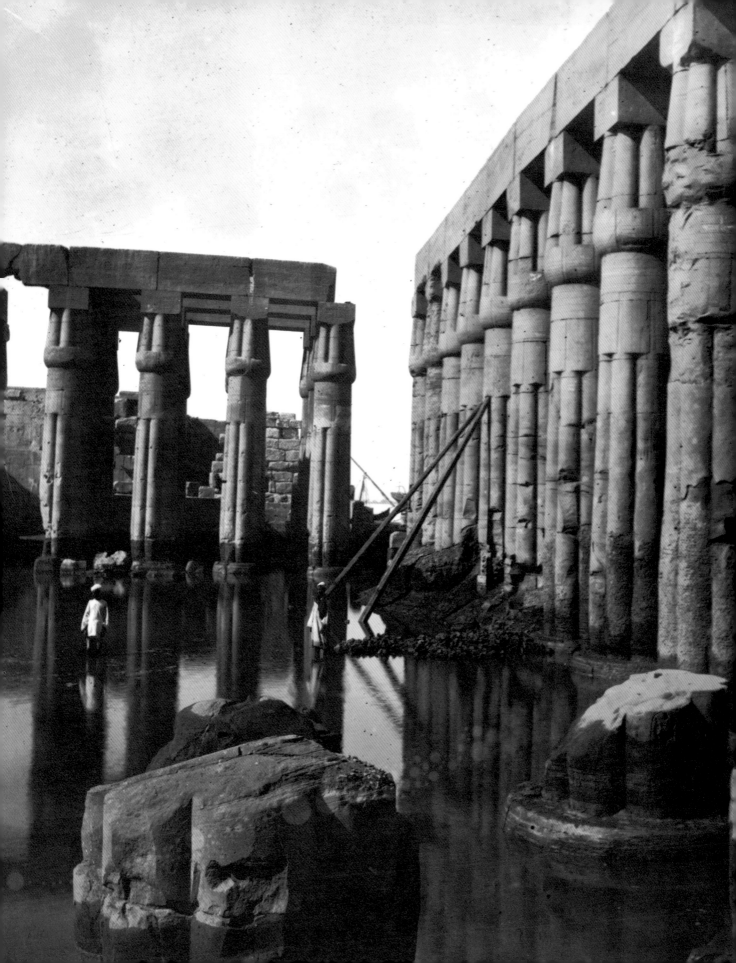

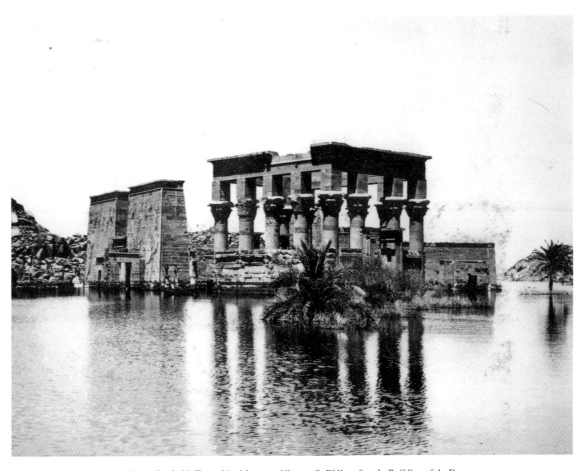

61. Anon. (probably Zangaki with name obliterated). Philae after the Building of the Dam.
The album (Meadhurst) containing the prints suggests they were taken in the early 1900s because their
bluish colour is untypical of earlier photography. In 1898 work began near the First Cataract to build a
dam and reservoir at Shellal. Philae, which had been flooded annually during the inundation, was then
permanently surrounded by water and not expected to survive.

Left

*60. Antonio Beato. Court of Amenhotep III at Luxor during the
Inundation. c. 1870.*
The large negative 16 x 20 inches shows the waters of the Nile flooding the
temple area. From the marks on the columns the waters have begun to
subside. This large negative catches the detail of the steam and sailing boats
in the centre of the picture, moored some thirty foot higher than usual.

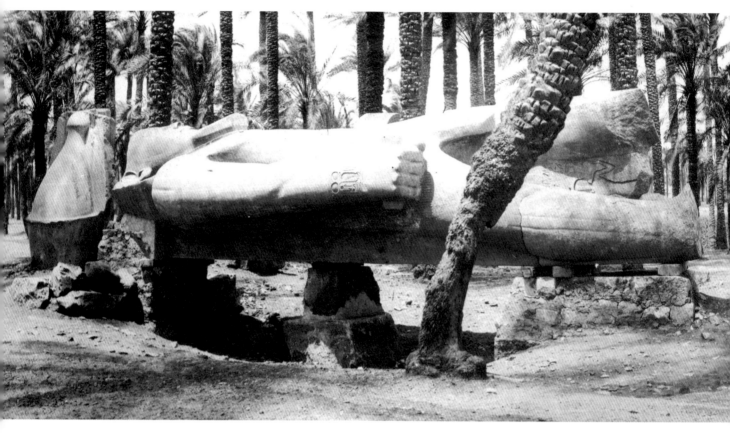

62. Zangaki. No. 409. Memphis, Statue of Rameses II. c. 1880.
It is hard to comprehend that Memphis was once both the capital and
largest town in all Egypt. When the temple of Ptah was demolished the
statue of Rameses II was toppled but it still remains of enduring interest.
Murray's 1900 guide says, "The expression of the face, which is perfectly
preserved, is very beautiful . . . in order to see the face it is necessary to
climb on to the breast of the figure."

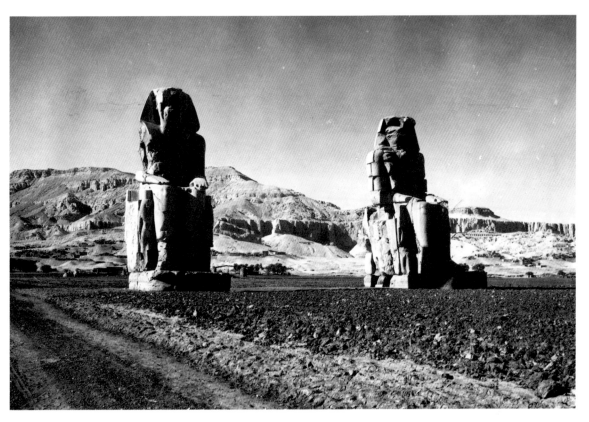

63. Antonio Beato. The Colossi of Memnon. c. *1880.*
The right-hand statue is still called the Singing Statue after the claim that as it was
warmed by the sun at dawn it produced a singing sound. Unfortunately it has not sung
since 27 BC when it was toppled in an earthquake. When repaired, alas, it sang no more.

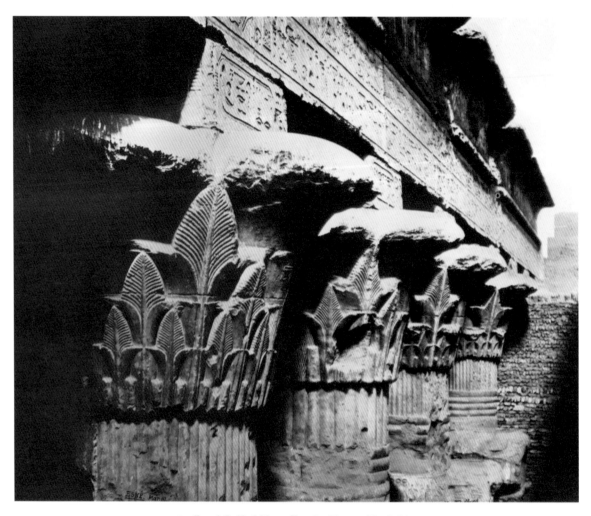

64. Francis Bedford. No. 27. Temple of Esne. 15 March 1862.
Esne was an important staging post for the Sudan trade until that declined. The temple was partly
excavated by Muhammad Ali in 1842. At the time of this photograph much of the temple was covered
with rubble and recently built houses. The rubble and excavation scaffolding enabled Bedford to take
this picture of the capitals of the pillars of the Hypostyle Hall.

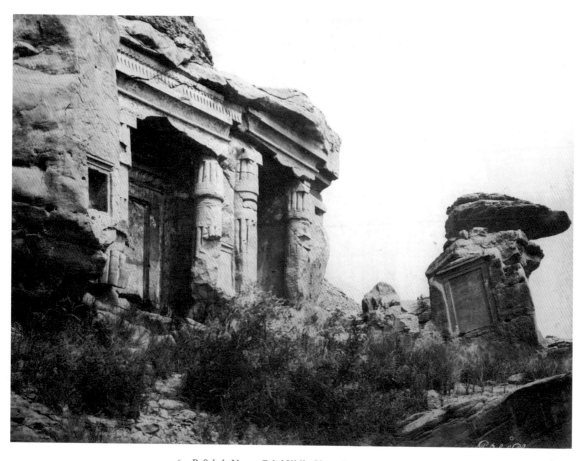

65. P. Sebah. No. 93. Gébel Silsila, Upper Egypt. Before 1875.
"The Stone of the Chain" as the name translates is said by Arabs to originate from an ancient king
fastening a chain across the river to stop all boats. At this point the Nile is only 1095 feet wide! Silsila is a
Roman transcription of the old Coptic name and it dates from the Nineteenth Dynasty (c. 1300–1230 BC).
The town was the headquarters of the officials who were in charge of the convicts working in the nearby
sandstone quarries.

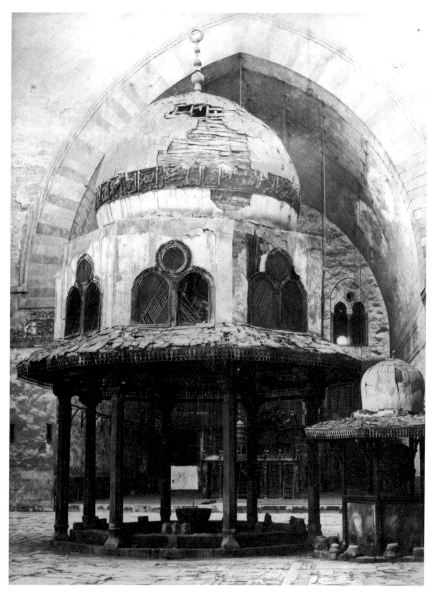

*69. P. Sebah. No. 18. Fountain of Ablutions of the
Mosque Sultan Hassan, Cairo. Before 1875.*
There are said to be 264 mosques in Cairo, but this one, immediately
below the Citadel, is regarded as one of the greatest achievements of
Islamic architecture. It was completed in 1360 after 3 years at the cost
of £600 a day. It is said that the king ordered the hand of the
architect to be cut off so that this building would remain unique.
Muslim worship demands ritual washing before prayer so that the
fountain, or *fawwarah*, is the focus of the courtyard.

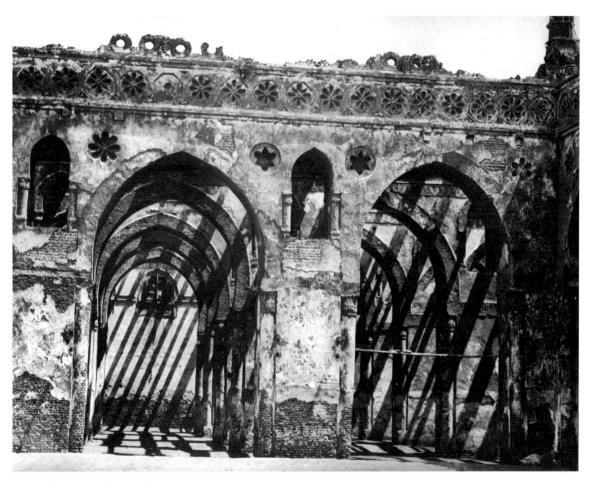

*70. P. Sebah. No. 13. Gallery of Mosque Touloun,
Cairo. Before 1875.*
Apart from one mosque in Old Cairo this is supposed to be one
of the oldest in the city. The architect was a Christian prisoner
who based the design on the mosque at Mecca as it was then.
The cost is believed to have been £72,000. At one time it housed
a university. The central court was 100 yards square and
surrounded on three sides with long galleries and arcades.

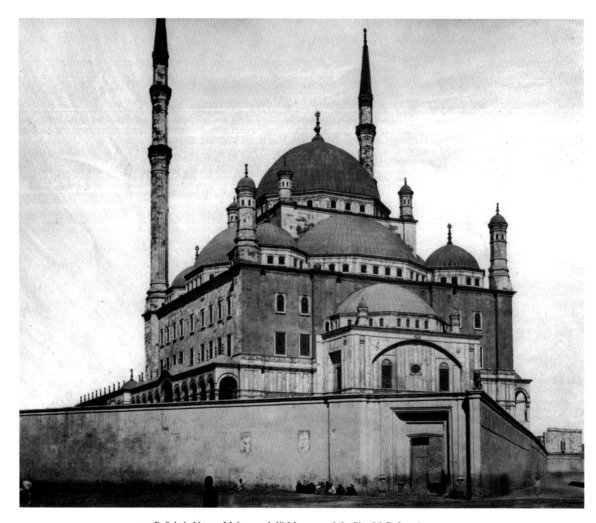

71. P. Sebah. No. 10. Mohammed Ali Mosque and the Citadel. Before 1875.
The mosque still dominates the skyline of Cairo but at the time of this photograph was
barely twenty years old. The site was that of the old palace of Saladin that was blown up
in 1824. Work on the mosque was not quite finished in 1857. Murray's 1900 guide is
scathing: "Its style is a bad imitation of the Mosque of Nasr Osmaniya in
Constantinople. The architect was a Greek."

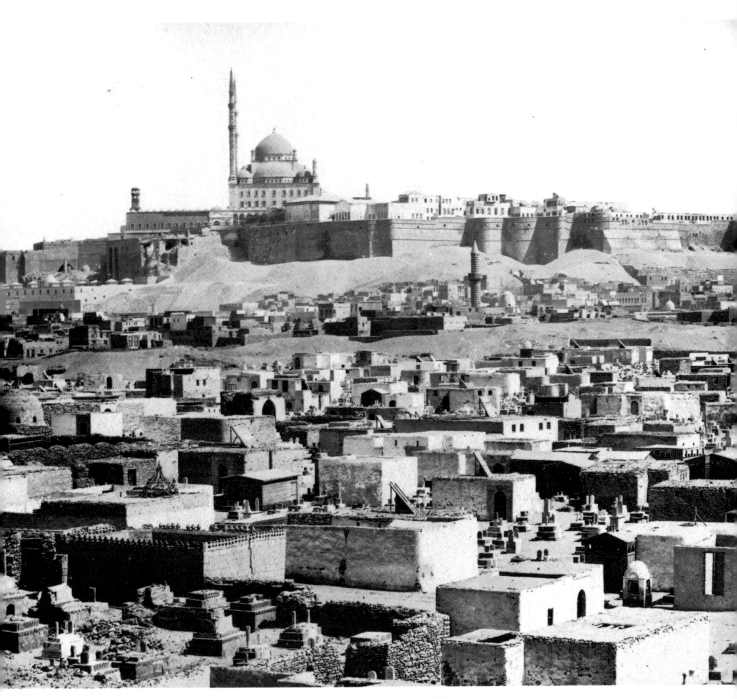

72. Bonfils. No. 53. View of the Citadel and Arab Village, Cairo. c. 1865.
This unusual view of the Mosque of Muhammad Ali shows the walls of the
Citadel particularly well.

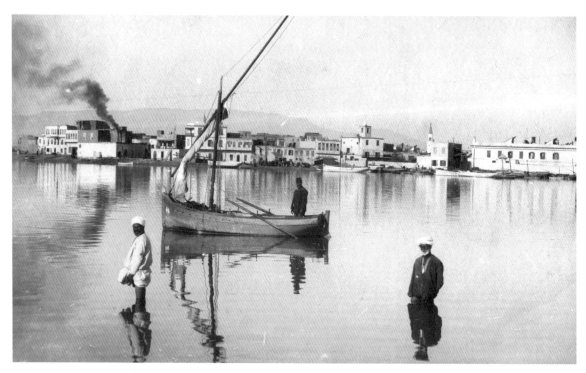

73. Zangaki. No. 31. High Tide at Suez. c. 1880.
The almost surrealist image is remarkable for the detail in the ripples suggesting a short exposure not in keeping with the series number 31, which would suggest a period when such exposures were not possible. This was a popular photograph. It was used later as a postcard and its almost identical companion entitled "Panorama of Suez and Tacka" was made for Arougheti Bros of Suez and sent postmarked 1906 by a Mr Mason who writes to Mrs Mason of Norwich that he has had two days there playing tennis!

74. Georgiladakis. Spring of the Pool of Moses at Suez. 1890s.
Legend claimed that it was here that Moses struck the rock and the water flowed. There is another Pool of Moses near Cairo and a more probable one, historically, in Sinai. This small oasis had at this time been surrounded by smart houses and was known as "The Richmond of Suez", very suitable for picnics.

75. *P. Sebah. No. 117. The Entrance to the Canal
at Port Said. 1869.*
The ship "dressed overall" and the incomplete state of
the buildings suggest that this was taken at the same
time as those pictures known to be of the opening of
the Suez Canal in 1869.

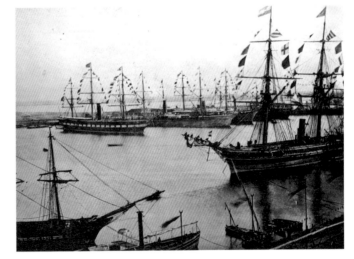

76. *P. Sebah. No. 113. Untitled, although no. 114 in
the same album is captioned Inauguration du
Canal de Suez. 1869.*
The opening of the Suez Canal in 1869 gathered together
ships of all nations. They moored here at Port Said before
making the ceremonial voyage along the canal to Suez.

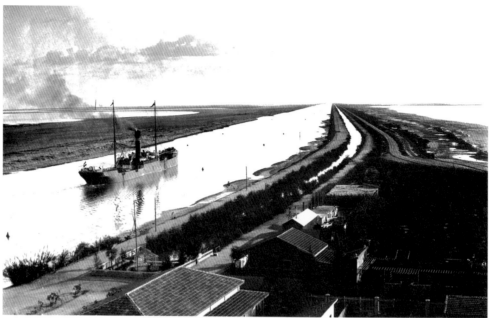

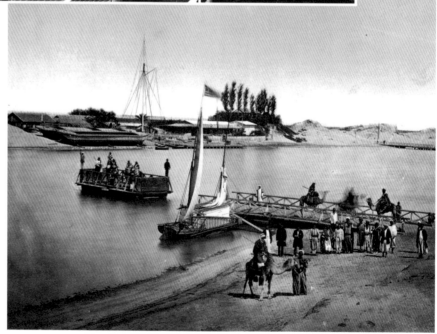

77. *Georgiladakis. No. 67.*
Sweet Water Canal and
Shipping Canal. 1890s.
Probably taken at the Port Said
end of the Suez Canal, before
Ismalia, where the Sweet Water
Canal from Cairo reaches the
Suez Canal. The print shows
signs that the name Peredis has
been touched out. To add to the
confusion the style is similar to
Arnoux. Perhaps both Peredis
and Georgiladakis were
previously assistants to one of
the Port Said studios.

78. *Anon. (probably Arnoux). No. 191. View of Kantara and the Floating Bridge.* c. *1880.*
Kantara was a village on the banks of the Suez Canal. The chain ferry was an important link on
the age-old caravan route to Syria. The small sailing-boat flying the Greek flag with a huge
ladder and large box structure may be Arnoux's floating darkroom. The written caption is
typographically similar to Arnoux's captions.

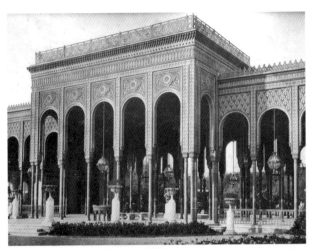

79. P. Sebah. No. 37. Pavilion of the Palace of Gezireh. Before 1875.

Murray's 1900 guide says, "Immediately opposite to Búlaq, on an island is the former Viceregal Palace of Gezireh, now an hotel. It was erected by Ismail Pasha regardless of cost, and gorgeously fitted up" (p. 394), and also "Gezira Palace Hotel from P [piastres] 75 a day, servants PT 40 a day. Well managed restaurant, Anglo-American bar, large garden" (p. 989).

80. P. Sebah. No. 33. Galleries of the Kiosk of Choubra [Shubra, near Cairo]. Before 1875.

Murray's 1900 guide says, "The Palace and Gardens were the work of Mohammed Ali, whose favourite residence it was, but the former was almost rebuilt by his son Halim Pasha. It has nothing to recommend it, being now utterly neglected. . . . In the centre is an open space with an immense marble basin, about 4 feet deep, surrounded by marble balustrades and with kiosks projecting into the water."

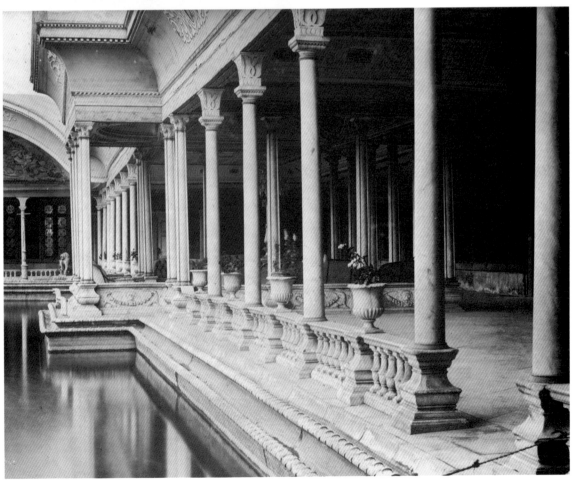

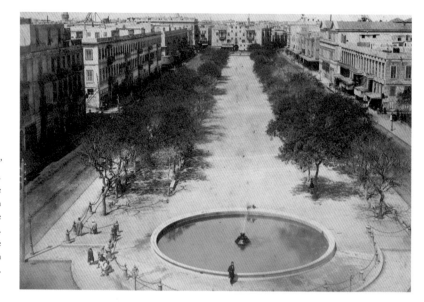

81. P. Sebah. No. 1. The Consuls' Square, Alexandria. Before 1872. The square was built around 1830. The English were granted the land to the north (on the right of this picture) and the French and Greeks had land to the south. The Armenians also had an area. At the eastern end was the Bourse from which this view was taken.

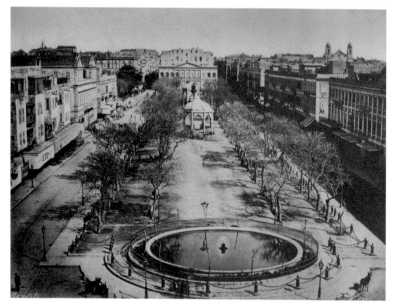

82. Bonfils. No. 226. La Place des Consuls, Alexandria. Between 1872 and 1882. This view taken from the other (western) end of the square shows the Bourse. Two kiosks have been built in the gardens and in the centre is the equestrian statue of Muhammad Ali. This statue was exhibited at the Paris Salon in 1872 and shortly afterwards placed in the square, in spite of Muslim religious opposition. It still has no inscription but the square was renamed Muhammad Ali Place. After the 1952 Revolution it became *Midan el-Tahrir* or Liberation Square.

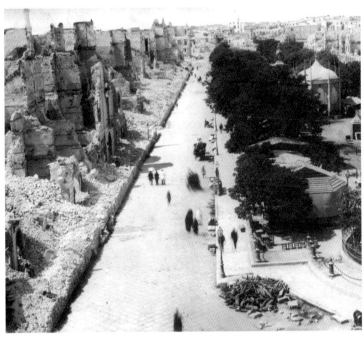

83. Anon. The Consuls' Square, Alexandria. After 1882.

Nearly all the photographs of both the riots and bombardment of Alexandria are anonymous, perhaps from fear of reprisals on the photographers' premises. The extensive damage is not the result of a naval bombardment, as shown by the untouched trees, kiosks and statue of Muhammad Ali. The British and French fleets had appeared off Alexandria on 20 May 1882, to show support for the Khedive. When the nationalist minister of war, Muhammad Urabi, refused to stop repairing the harbour forts, they were bombarded by the British on 11 July 1882. The next day and the day after the troops left the town and the Egyptian population rioted, burning and looting not only the square but any European premises.

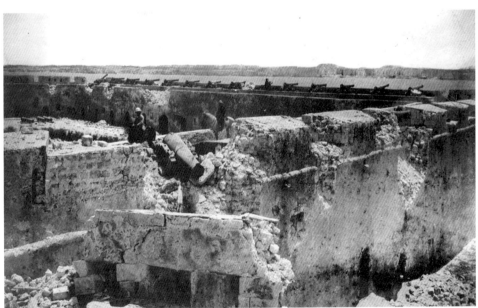

84. Anon. (Zangaki). Fort Pathos, Alexandria. 1882.
Although not signed the caption is exactly in the style of Zangaki. This shows the aftermath of the British bombardment of the forts at the entrance to the harbour. The refusal of the French to participate can be seen, now, as the beginning of the decline of French political influence.

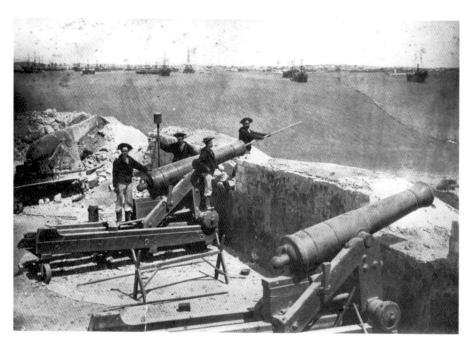

85. *Anon. (probably Zangaki). British seamen manning one of the Egyptian guns captured after the bombardment of Alexandria in 1882 with ships of the British fleet in the background.*

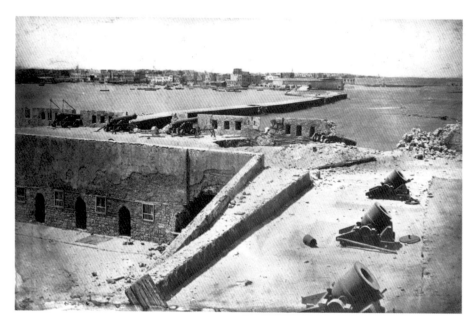

86. *Anon. (probably Zangaki). The mortars and cannon of the bombarded fort of Alexandria with a view of the breakwater and harbour with the town behind. 1882.*

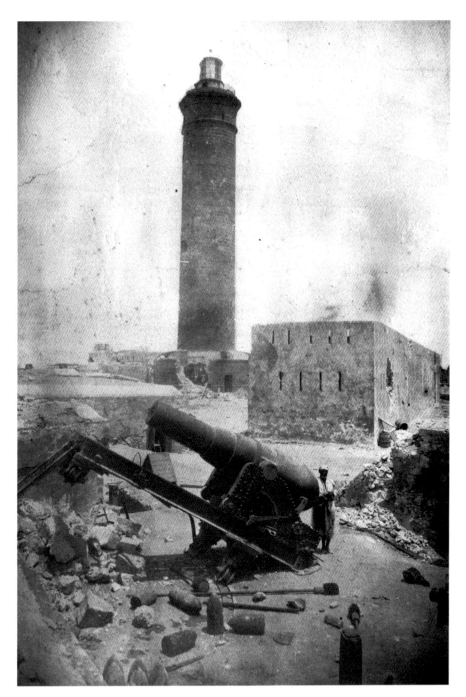

87. Anon. (probably Zangaki). The Bombardment of Alexandria. 1882.
A striking photograph showing one of the heavy guns uprooted and the lighthouse at
the end of Pharos Island at the harbour mouth.

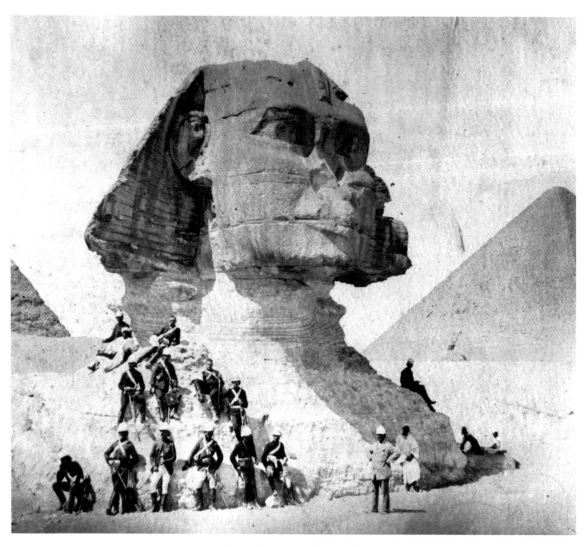

88. Anon. Troops on the Sphynx. c. 1882–5.
A small group of soldiers with no signs of any excavation of the sand in front of the
Sphinx. In the 1860s there was a depression in the sand in front of the head which by the
1870s had refilled with sand. It began to be cleared from the late 1880s, but it was not until
around 1900 that the paws of the Sphinx were finally cleared. There are two civilians
present. One could be Mr Zangaki again and the other who has a book or sketch pad on
his lap might, to an active imagination, be a war correspondent.

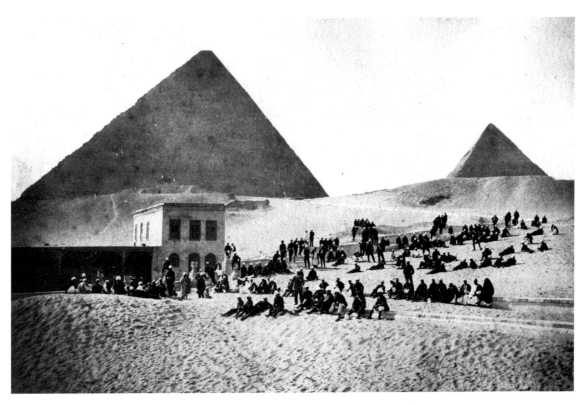

89. Anon. Troops Before the Pyramids. c. 1882–5.
Some very relaxed troops taking their ease before the pyramids. Unusually, on the right,
some Egyptians are sharing a bench with soldiers. Such a photograph would not normally
be signed. The civilian standing in the centre looks remarkably like Mr Zangaki.

90. *Colonel St Leger.*
79th Camp, Korosko. 1884.
The army camp of the 79th Cameron
Highlanders was to grow as more
troops arrived. The whole of
Korosko has now disappeared under
Lake Nasser.

91. *Colonel St Leger. Korosko*
from the Heights. 1884.
The bell-tents are for the British
troops waiting to go to the relief
of General Gordon at
Khartoum. The camels in the
native village were intended to
be an overland relief supply
force. The military operation
was, in fact, cancelled.

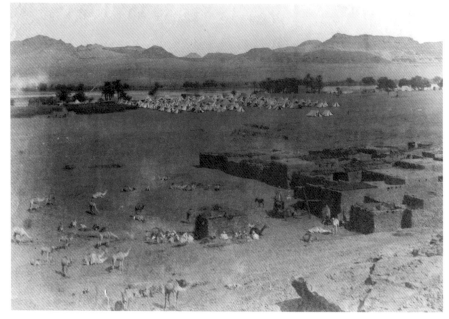

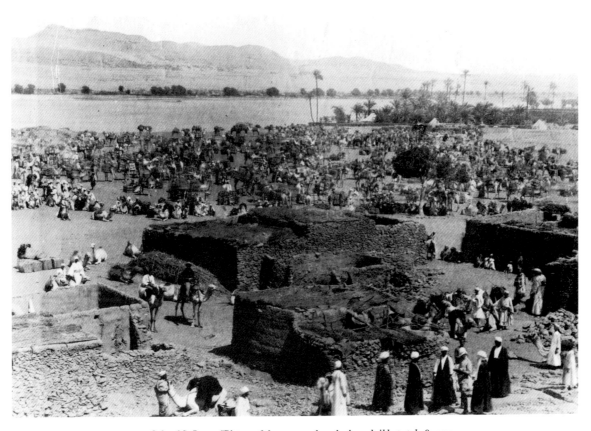

92. Colonel St Leger. "Picture of the 700 camels and minor sheikhs to take 80,000
rations to Abu Hamed, last assembly before dispersion. Major Rundle (right
foreground) reading General Wolseley's order to disperse. Korosko. March 1885."
Abu Hamed was up-river between the Fourth and Fifth Cataracts and could be reached by
steamers from Khartoum. An earlier camel train had been sent but arrived two days after
Gordon was killed in January 1885.

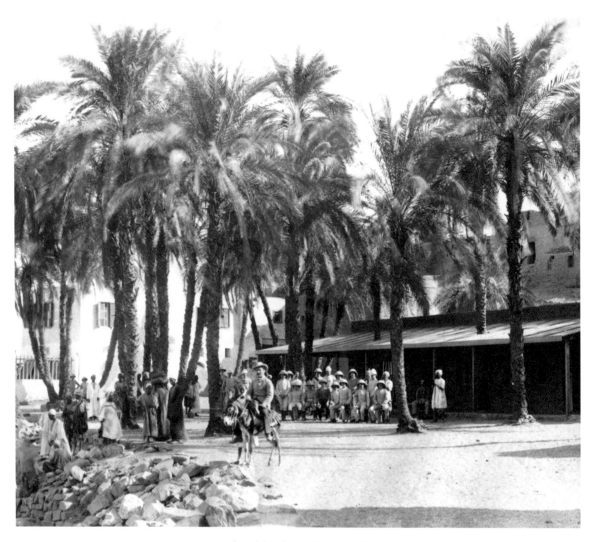

93. Anon. Main Guard, Aswan. c. 1882–5.
A strange photograph that may be earlier than the Sudan Campaign. Although the
enemy were never expected to attack Aswan, a Main Guard of twenty soldiers does seem
to be inadequate. The building behind the troops erected around the palm trees is
presumably the barracks or the guardroom.

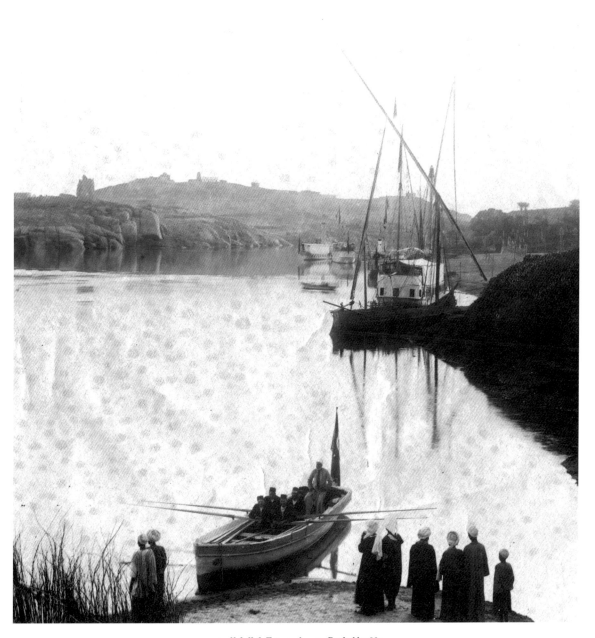

94. Abdullah Frères. Aswan. Probably 1887.
The scene appears to be the landing of an official with sailing and steamships in the
background. The official may have been the Khedive Tewfic Pasha.

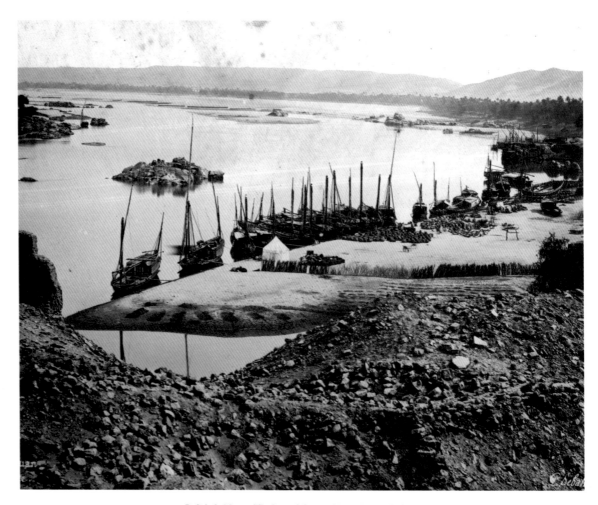

95. P. Sebah. No. 95. The Port of Aswan, Upper Egypt. Before 1875.
Aswan was once an important town with granite quarries, a staging post for the slave
trade and a producer of fine wines. Nowadays it is known for its hotels, being the port in
Upper Egypt from which excursions are made to Philae and Abu Simbel. The white tent
on the foreshore may be Sebah's darkroom making another appearance.

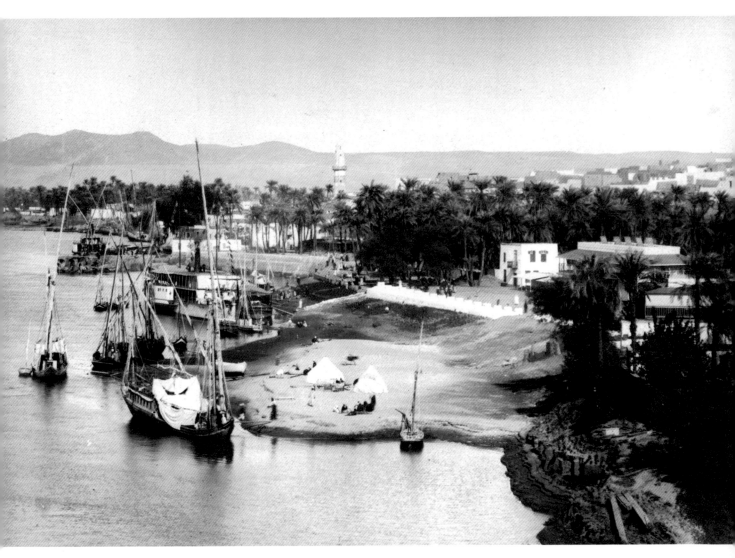

96. P. Sebah. Assouan, Vue Générale. Before 1875.
This location just south of Aswan has always been popular with photographers as it
provides a fine view of the waterfront with its variety of cargo and passenger *dahabiya*s.
Aswan's population was then 8–9,000, including tourists, compared to Cairo's 400,000.
Today Cairo is the largest city in Africa with a population of 6.8 million.

Life in the Countryside

The early photographers in Egypt concentrated on the antiquities, the glory that once was Egypt. They were Europeans who spoke no Arabic. Their daily contact was through interpreters. Those who travelled privately were taken care of by a dragoman who was more likely to be Greek than an Egyptian. Tourists who travelled with Thomas Cook were even more isolated from the ordinary Egyptian people. In the hotels and on the steamers the senior staff were usually not Egyptian. Well-to-do Egyptians were akin to the tourists in that they spoke English or more usually French at home rather than Arabic. When they went out they travelled in coaches with the saïs (stableman) running ahead to clear a pathway through the local populace.

Lucie Duff Gordon, who lived in Egypt for some years, made great efforts to make contact with the natives. She was an exception in that she lived in her own house at Luxor. She welcomed local contacts and avoided Europeans whenever possible.[1] The ordinary tourist, however, would get his only glimpse of rural life from the deck of his Nile boat. This was appropriate, for the Nile was the lifeblood of Egypt. Women gathered on the banks to gossip while collecting water, filling the gourds that they carried on their heads. Men would come separately with buffalo skins tied across their backs. To irrigate the fields young men and boys toiled endlessly at the *shadouf*, a bucket on a long pivoted pole, lifting the Nile water into the irrigation channels. Less laborious and more efficient was the *sakkia*, a water-wheel-style long chain of buckets operated by a blind-folded buffalo plodding round a circle, urged on by a small boy.

The major irrigation event was the annual inundation of the Nile. The river, swollen by rain from far beyond Nubia, flooded the fields with water and rich, life-giving alluvium. The inundation was measured by stone-carved Nilometers, which showed the increase in the water level. Some of the finest views of the pyramids were taken by the resident photographers over the flooded fields. The inundation was of vital importance below Cairo, and the Nile Barrage was built to control the flow of water, particularly when the Nile rose less than usual. Egyptologists and European photographers stayed away during the hot summers and this explains why there are no early photographs showing the inundation.

Paradoxically, the earliest photographs of rural folk were taken in the towns. In the 1870s exposures were still long, even though portrait lenses were faster than landscape ones. The demand for

"native types" was met by posed studio portraits of varying degrees of authenticity. The backgrounds were standard painted backcloths, often imported from France. An imitation scene based on Versailles might be acceptable for a portrait of an Egyptian or Turkish official or even a family group, but makes an incongruous background for a belly dancer. Other outdoor backcloths resembled a French park more than any place in Egypt and only rarely, after the 1880s, did the backcloth depict the pyramids. If the incompatible backgrounds are disregarded, the people presented look remarkably authentic, although rigid either from fear or because of the studio headclamp.

NOTE
1 Lucie Duff Gordon, *Letters from Egypt*, 3rd edn (London, Brimley Johnson, 1902). The letters were written 1862–9.

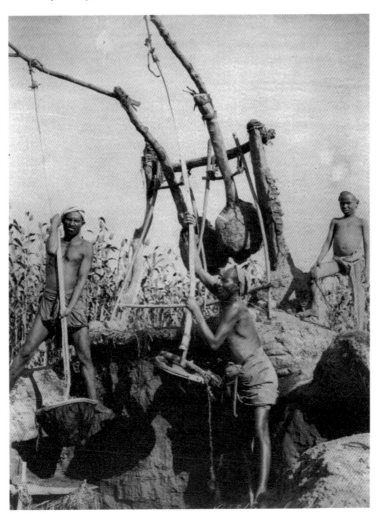

97. Zangaki. No. 560. Chadouf of Upper Egypt. c. *1885.*
Unlike the *sakkia* that needed buffalo and small boys to drive them, the *shadouf* needed strong men. The one shown here is a double *shadouf* consisting of two leather baskets each suspended from a counter-balanced pole. The lift is about eight feet so that there needs to be at times a vertical series of three or four *shadouf*s to raise the water to a usable height.

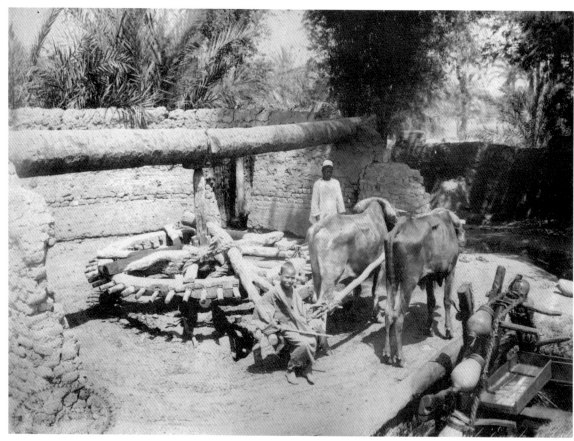

98. Zangaki. No. 88.
The Sakkieh of Upper Egypt. c. *1890.*
The blind stamp on reverse shows that the print was
supplied by B. F. K. Rives, No. 74, but there is also a
rubber stamp "The English Library (G. G. Zacharia)
Cairo, Egypt". Zacharia and Livadas are listed in
Murray's 1900 guide as opposite Shepheard's Hotel. It
also lists as photographers Abdullah Frères, Rue Kamal
Pasha, and Lekegian near Shepheard's Hotel, as well as
two others – unknown to me – Heymann next to
Shepheard's Hotel and Katzenstein in the Muski, both of
whom may just have been agents.
The *sakkia* was an important irrigation method in Upper
Egypt – usually buffalo turned the toothed wheel, which
in this case was linked under the platform to a continuous
chain of pots which emptied into the irrigation trough at
the top of the circuit. The water could be lifted a greater
distance much faster than by the *shadouf.*

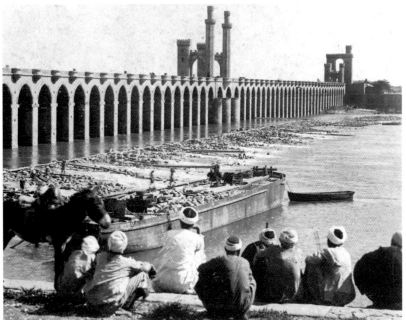

99. *Abdullah Frères. No. 360. General View of the Arcade of the Barrage. After 1883.*
The squatting men are watching a busy scene with large rocks being unloaded from a barge. The barrage was built twelve miles below Cairo to try to regulate the water flow. Originally begun in 1835, by 1865 the existing works had been shown to be inadequate. It was altered from 1883 by British engineers, so any photographs of it are not earlier than that date.

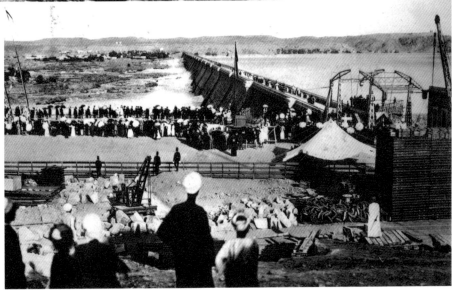

100. *Anon. The Barrage at the First Cataract, Aswan. Probably 1902.*
The canal and locks, which allow boats to pass through, are marked by the two rows of spectators. The scene is almost certainly the official opening ceremony for the barrage in 1902 after four years' work. This barrage was heightened in 1912. There were other barrages at Assiut (1902) and Isna (1909) which mark the first attempts to control the inundation of the Nile .

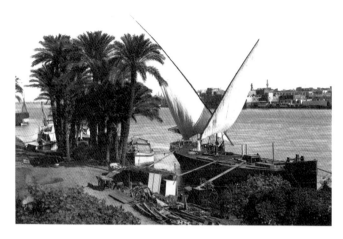

*101. Georgiladakis. No. 425.
Bord du Nil. c. 1890.*
The caption writer seems to have
given up on the complex photograph
which appears to give a glimpse of
real life on the Nile. The central boat
is metal built with a motor as well as
picturesque sails. It is a cargo boat
but the scrapyard on the bank gives
no clue as to what it carried.

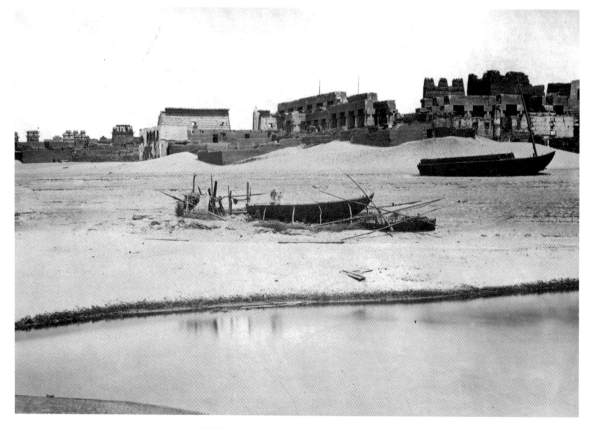

102. P. Sebah. No. 56. Boat Building at Luxor. Before 1875.
The inundation of the Nile meant that a start at boat building could be made when the
Nile went down and the completed boat floated off when the Nile next rose.

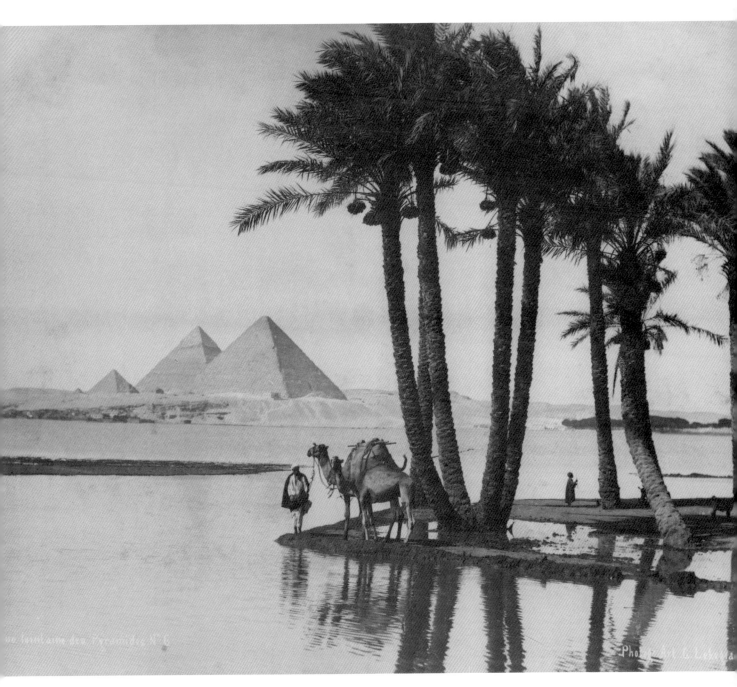

103. G. Lekegian & Co. No. 6. Distant View of the Pyramids. c. *1891.*
It is perhaps typical that the caption does not mention the flooding from the inundation.
It was simply part of everyday life and therefore unremarkable.

104. Bonfils. No. 1419. The Avenue to Giza during the Flood of the Nile. c. 1880.
The narrow strip of inhabited land is surrounded by Nile flood water
at the height of the inundation.

105. G. Lekegian. No. 344. Forest of Palm Trees, Sakkara. c. 1890.
The commercial demands of the tourist trade meant that all photographers had to have a
basic stock of images: the historic sites, local views and different native characters. It is
refreshing when a photographer breaks loose and photographs something that interests
him, perhaps in the hope that someone else will enjoy it too.

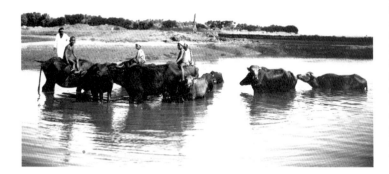

106. Bonfils. No. 741. Buffaloes Bathing in the Nile. c. 1870.

To the dwellers on the Nile the buffalo (ox) was far more important than the camel, with even the donkey coming before the camel. They were used for all the hard work and were well looked after. The bathing not only cooled the buffalo but also cleansed their skin from ticks, etc. Lucie Duff Gordon in a letter written at Luxor, 15 May 1864, describes the spread of the cattle disease. "The distress in Upper Egypt will now be fearful. Within six weeks all over cattle are dead. They are threshing the corn with donkeys, and men are turning the sakiahs and drawing the ploughs, and dying by scores of overwork and want of food in many places. The whole agriculture depended on the oxen and they are all dead." Cattle dead in and near Luxor were in excess of 24,000 in a matter of weeks.

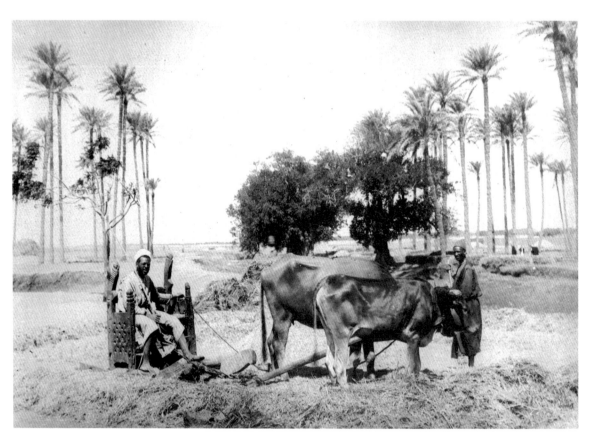

107. Zangaki. No. 483. Threshing Wheat. c. 1875.
In the centre of the circle is the unthreshed wheat and the heavy sledge is pulled round over it.
After threshing, the straw is put outside the ring and replaced by unthreshed wheat.

*108. Georgiladakis. No. 285. Arab Women Refilling
their Crocks from the Nile. c. 1895.*
The antiquities in the background suggest the Upper
Nile, and the "Arabs" may be Nubian. The Nile was the
only source of drinking water for most of Egypt. Lucie
Duff Gordon pronounced it delicious (unfiltered) but
only if drawn from the centre of the river.

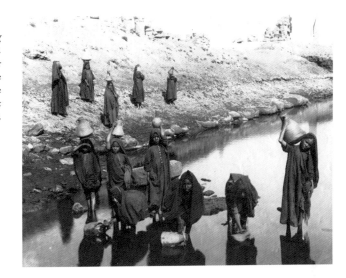

*109. Georgiladakis. No. 289.
Group of Water Carriers. c. 1895.*
There is no indication on the caption, but the photograph
was taken in Upper Egypt and the natives were Nubian.
The caption is unusual in that it is one of the few in
English, which would tend to confirm a date in the 1890s.

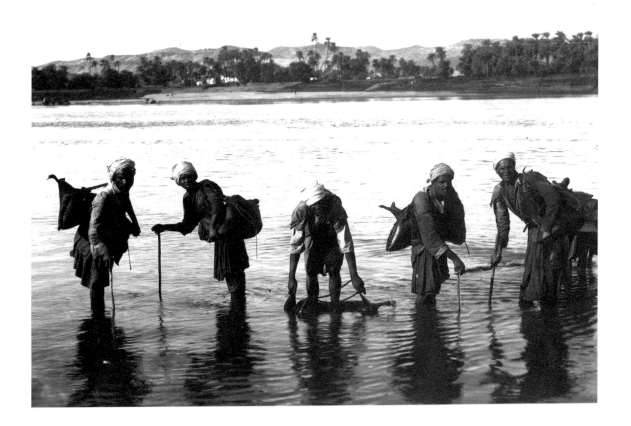

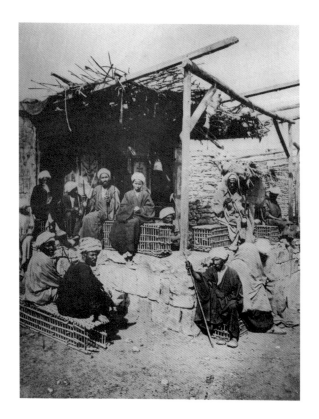

110. P. Sebah. No. 43B. Arab Café, Cairo. Before 1875.
This scene is in Cairo but could be anywhere in Egypt and is extremely rare for this date. Native men were usually unwilling to be photographed and perhaps for this reason one man has covered his face with his cloak. The customers seem to be sitting on the ubiquitous chicken baskets and curiously there are no tea or coffee cups visible. It would be many generations before, even in enlightened circles, women would have been able to join the men, even if they had wanted to.

111. Georgiladakis. No. 20. "The Voyage in the Desert". c. 1890.
While hardly taken in the desert, the photograph does seem to show authentic Bedouin and camels with their typical rope panniers. Although one of the last photographers to work before the end of the century Georgiladakis' pictures are important and unique in their documentary approach to Bedouin life. Typographically his captions are interesting because they resemble those of Zangaki who, significantly, ceased producing large prints when Georgiladakis started to do so.

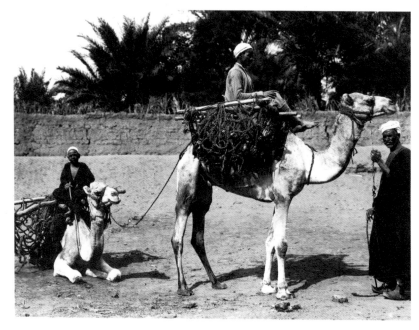

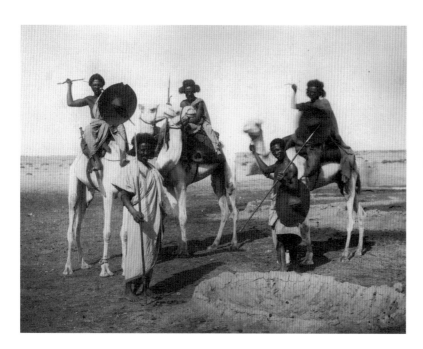

112. Anon. Bisharin Warriors. c. *1870.*
No caption to this photograph exists and the
warriors are probably genuine even if the
photographer told them to brandish their
weapons. Any caption might have explained
the dry mud or clay pools. The photograph
may be early because even in the Sudan
sunshine the shutter speed has not stopped
the movement of the camel on the right or
the shield of its rider.

*113. Bonfils. No. 142. Desert Scene, Arrival of the Camel Riders
at the Tribal Encampment.* c. *1870.*
The scene could be anywhere from the Lebanon to Algeria but there
are surprisingly few photographs of genuine Bedouin encampments.

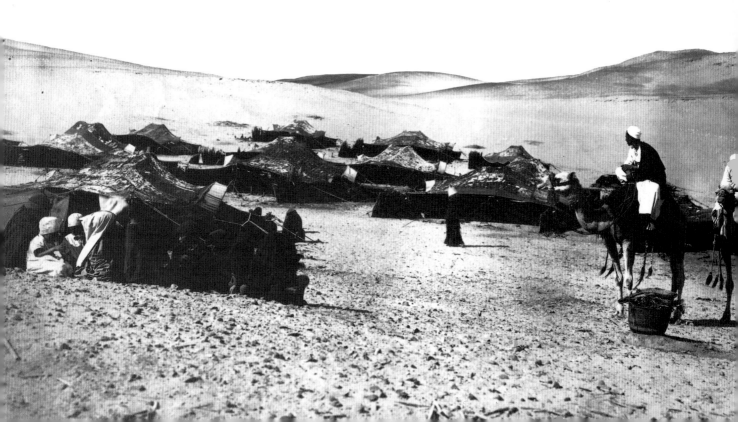

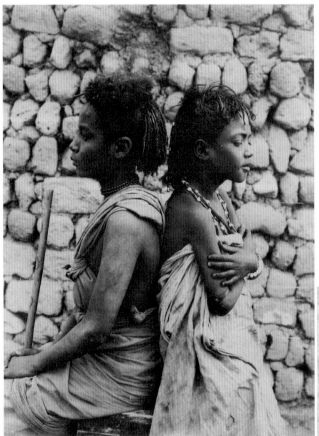

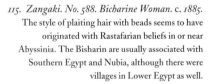

114. Zangaki. No. 582. Two Sudanese Women. c. 1880.
The ordinary people of Egypt were the fellahin who formed 75 per cent of the population. They are the country people, looked down upon or ignored by those who served the tourists. The black Nubian peasants and the lighter-coloured Sudanese were generally believed to be superior to the Egyptian peasant, and were considered to be more exotic and therefore of greater photographic interest. In view of the racial mixture of Egypt it was not thought necessary to be precise in captions.

115. Zangaki. No. 588. Bicharine Woman. c. 1885.
The style of plaiting hair with beads seems to have originated with Rastafarian beliefs in or near Abyssinia. The Bisharin are usually associated with Southern Egypt and Nubia, although there were villages in Lower Egypt as well.

116. H. Arnoux. Untitled. c. *1880.*
The same two natives shown here in a similar studio set are described as Abyssinian
warriors on a colour postcard. On other pictures the man on the left is called Nubian and
the other one a "Fuzzy Wuzzy". The picture was taken before the "fuzzy-wuzzies" were
immortalized by Rudyard Kipling.

Life in the Towns

WHILE IN THE COUNTRY life revolved round the Nile, in the towns it centred on the souk, the covered market, and the shops surrounding it. Every morning donkey carts would come from the outlying villages with fresh vegetables for the open market. Men and women would go to the market and afterwards the men would go to cafés, where mint tea was served.

Most noticeable in photographs of any Cairo street scene is the *mashrabiya*, the lattice-work balcony, which allowed air to filter through the house and from which the women could watch the world go by without being seen themselves. There is a whole series of photographs of street life taken in what appears to be, at first sight, an ordinary street. Closer examination reveals it to be an out-of-doors studio set and the panel of *mashrabiya* is at ground level, with small boys poking their heads out of the window.

Other posed photographs were not all that they seemed to be. Egyptian women were usually unwilling to pose, particularly if they were Muslim, and had to be portrayed by those on the fringes of society, including prostitutes. The lack of models sometimes resulted in the same woman appearing in different costumes, as Arab, Bedouin, Druse Christian or Jewess! Tourists were looking for souvenirs and if the costumes looked

117. Zangaki. No. 544. Coming to Market. c. 1885.
The scene is probably the road from the villages near Giza. The woman is bringing chickens to market in the baskets with turkeys perched on top. The photographer has stopped them for the photograph. The woman looks straight at the camera, the little girl stands shyly, while the boy avoids the camera.

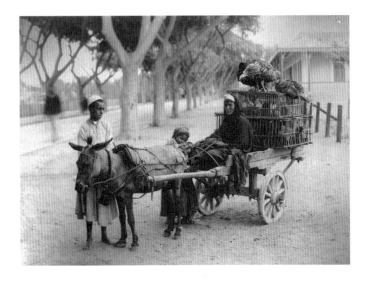

authentic they paid no heed to the faces. There were any number of people, Egyptian and non-Egyptian, willing to take part in this charade.

Nowhere is this more obvious than in the portraits of women seen on postcards at the turn of the century. The earlier, larger prints of the native people in the 1870s and 1890s had shown both males and females, many as full-length portraits. The postcards mainly featured the head and shoulders, dominated by women wearing the veil, which added to the mystery. The Turkish-style *yashmak* was simple and black but occasionally of open net, which looked more fashionable even if not within the strict bounds of custom. The traditional Egyptian *burgu* had a tube of leather at the bridge of the nose above the veil. The rural *hijab* was a scarf covering the hair and forehead, to be drawn across the face at the approach of a man.

Postcards of veiled women often had a slight sensual aura, those of the belly dancers being overtly more so. The true belly dance owes more to village folklore than to the Pasha's entertainment. The skill and subtlety of the belly dance could transform it into an art form.[1] There were photographs and postcards of the dance well before it became debased by Western attitudes into the vulgar music hall

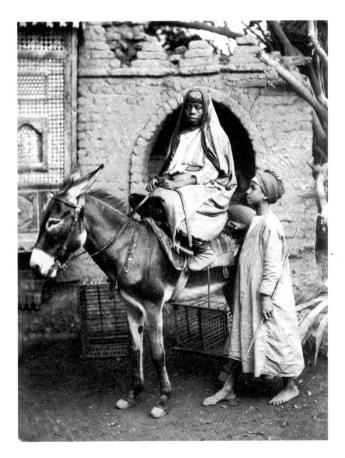

118. Zangaki. No. 501. Negro Woman on an Ass. c. *1880.*
As an illustration of Cairo French, the caption calls the ass *bouricos*; the French dictionary gives it as *bourrique*. The boy is frozen by his instructions, but the woman, probably from the south beyond Nubia, is splendidly disdainful. The background with its ground level *mashrabiya*, the brick arch and the twisted tree appears in many other photographs and postcards.

hoochy-coochy. This Westernization was accelerated by the ill-named "Little Egypt" at the Chicago World Fair in 1893.

Singers and dancers had their own hierarchy. Most of those seen in the photographs would be *bayadere* or *baladi* performing in public. Above them were the *almah* (plural *awalim*), more singers than dancers, usually performing for select private audiences. Below the *bayadere* were the *chaziya* or *cengi*, gypsies who performed anywhere they could. They sometimes combined their talent with prostitution, which led to the periodic clampdown on their activities and banishment of all dancing girls. This is reflected in coyly worded captions such as "Danse au Ventre", even on postcards intended for the English-speaking market. Some captions were even less explicit, such as "Oriental Dancer" or "Oriental Musician". What is most striking about these photographs is their down-to-earth quality and the absence of any orientalist fantasy.

NOTE
1 For a detailed discussion see Wendy Buonaventura, *Serpent of the Nile* (London, Saqi Books, 1989).

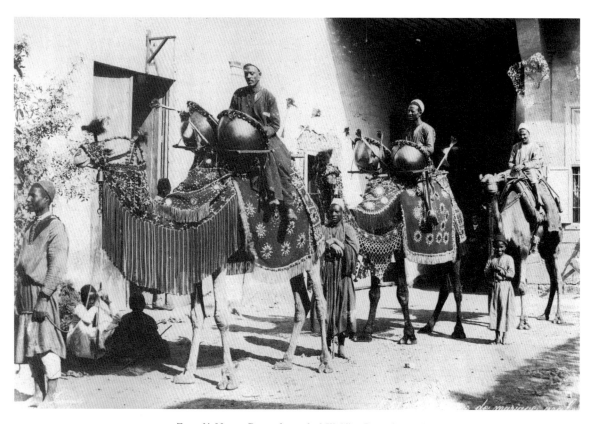

119. Zangaki. No. 517. Drums for an Arab Wedding Procession. c. 1885.
The camel-leaders and splendidly decorated camels suggest a wedding of some importance, as also
shown by the interest shown by the cigarette-smoking European observer in the background.

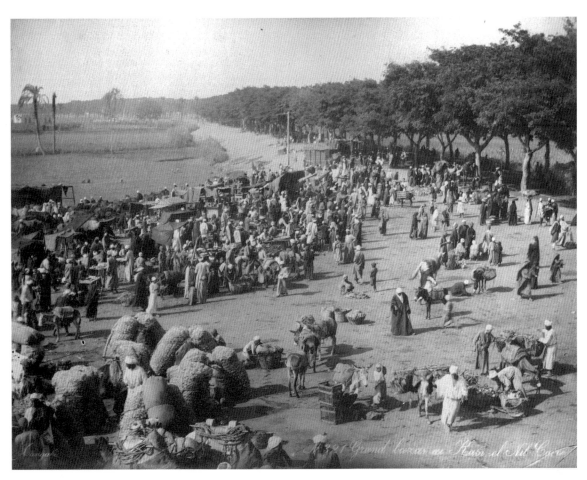

120. *Zangaki. No. 321. Grand Bazaar at the Kasr el-Nil Bridge.* c. *1880.*

The bridge was the most important in Cairo, being periodically opened to allow boats to pass through. If the caption is accurate, the market would have been on the island of Gezira in the centre of modern Cairo. The bridge is now officially the Tahrir Bridge but still popularly called the Kasr el-Nil.

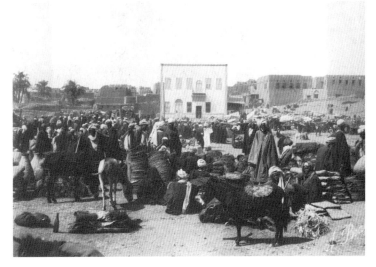

121. *Antonio Beato. Luxor Market.* c. *1890.*
Beato rarely photographed street scenes, so this view of the weekly market, almost on his doorstep, is exceptionally interesting.

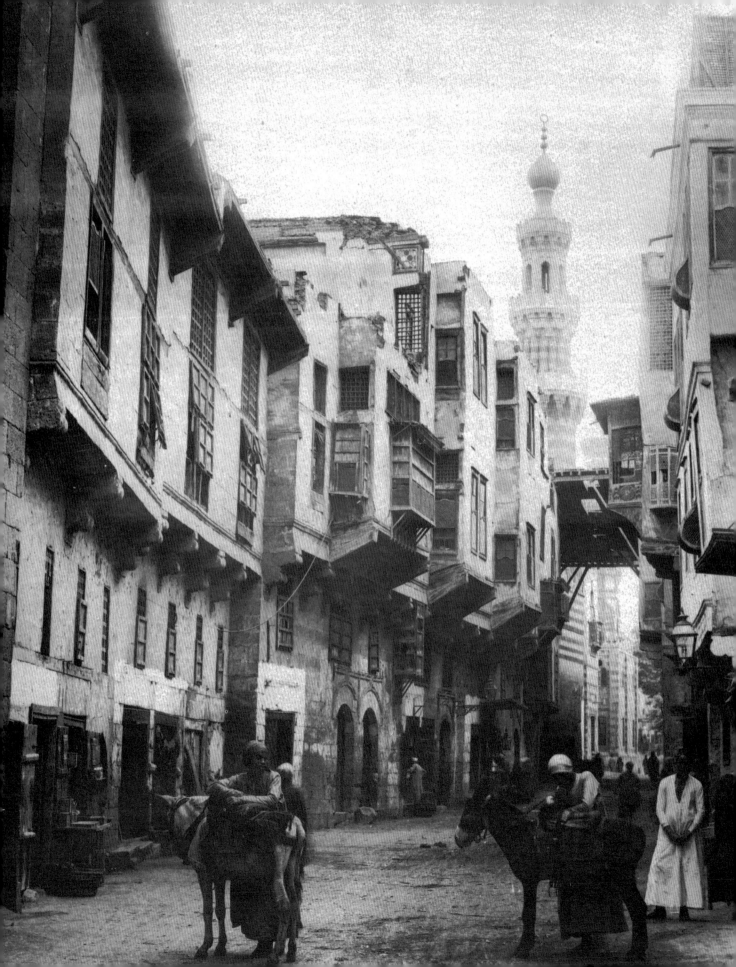

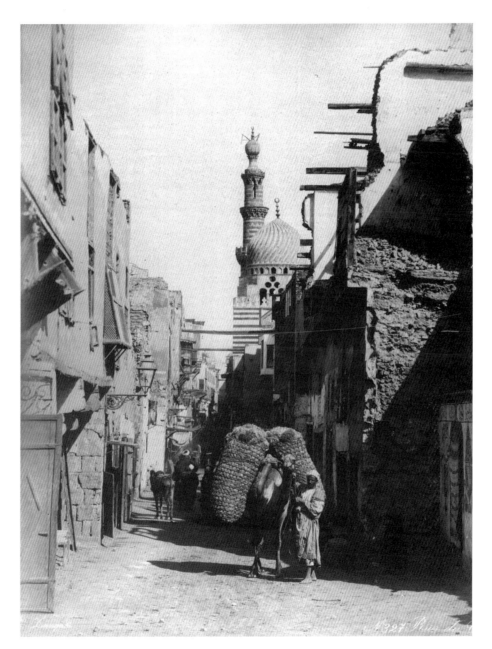

123. Zangaki. No. 327. Cairo Street.
The streets in Cairo were very narrow due to the
tradition of building for defence purposes. This
photograph shows an important street as it is fitted with
street lighting. Such pictures are almost impossible to
date. This is probably around 1890. The well-laden
camel is typical of these scenes.

Left

122. Zangaki. No. 371. Street in Old Cairo. c. 1880.
The overhanging balconies of *mashrabiya* are particularly evident in this
view. The name literally means "a place for drink" and comes from their
cooling function, as earthenware pots of water were placed in them to be
cooled by the breezes.

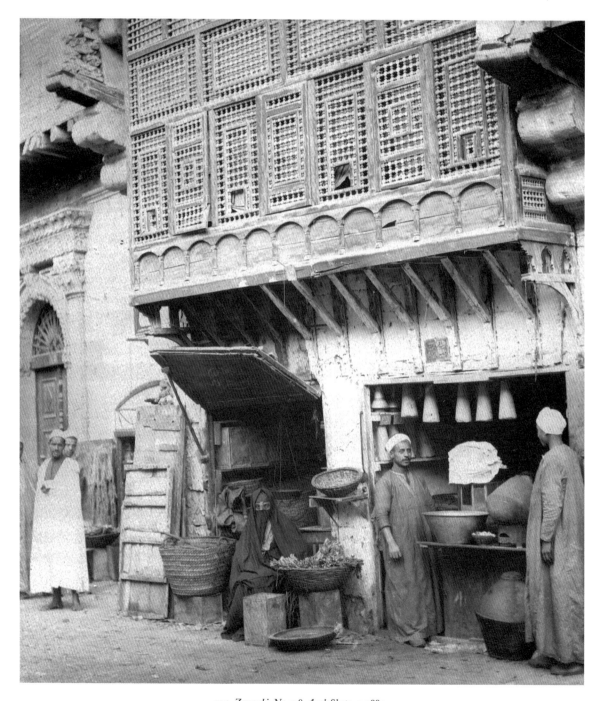

124. Zangaki. No. 538. Arab Shops. c. *1885.*
The ground floor is below a fine example of *mashrabiya* and consists of two or three shops. The veiled woman in
the centre seems to be selling vegetables. The two men on the right could be potters, to judge from the rows of
conical objects, whereas those on the left of the print have something unidentifiable hanging up.

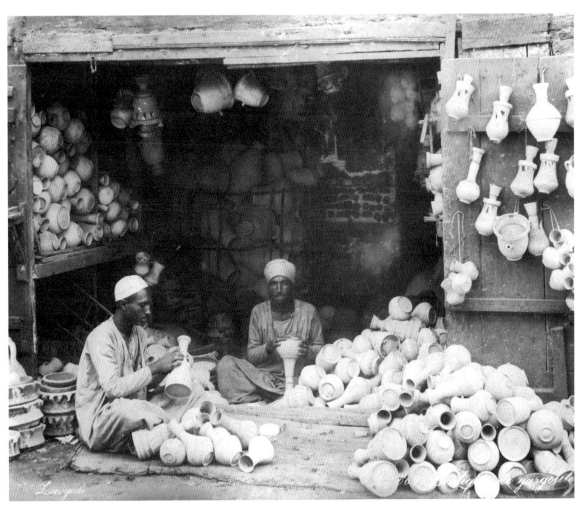

125. Zangaki. No. 569. Boutique de Gargoulettes. c. 1880.

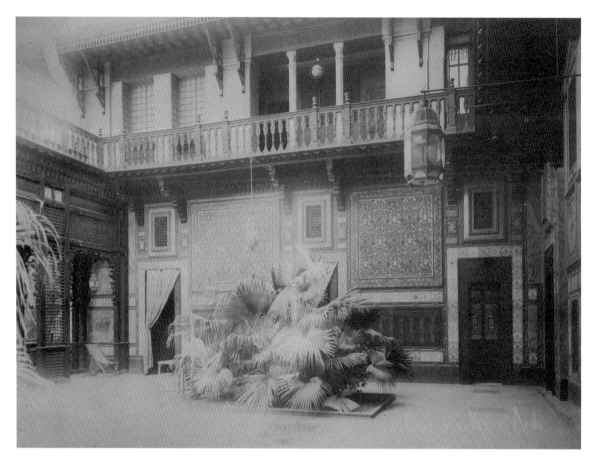

126. J. P. Sebah. No. 87. Courtyard of an Arab House. After 1885.
There are many street scenes showing the exterior of Egyptian houses which do not hint
at the elegance of their interiors. This is one of those rare views, obviously a superior
residence. The signature confirms it was taken after 1885, but the incongruous deck chair
may place it a decade later.

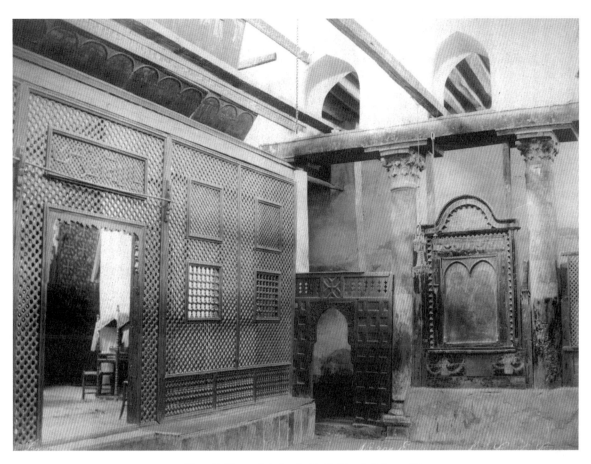

127. Zangaki. No. 301. Interior of a Coptic Church, Cairo. c. 1880.
Some twenty per cent of Egyptians are Copts. They are a Christian sect that in 451 were
pronounced heretical by the Roman Church but are still active, particularly in Egypt.
The screens separate men from women and the inner sanctum from the outer.
Photographs of the interior of Coptic churches, although not banned, are even rarer
than of Muslim mosques.

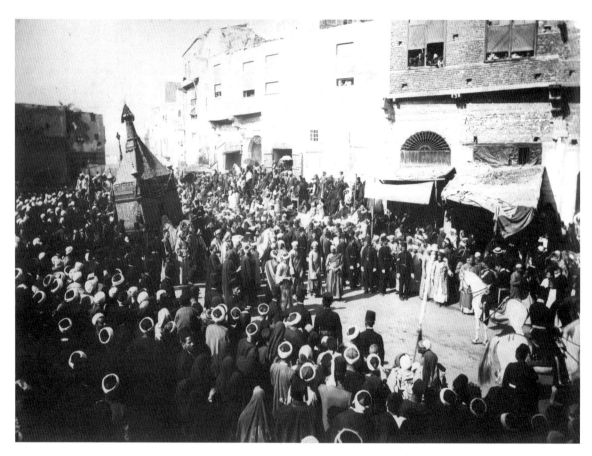

128. Anon. The Departure of the Mahmal from Cairo. c. 1885.
The police keep order as the high dignitaries gather. Finally, the Khedive arrives and makes obeisance
to the Mahmal and the pilgrimage to Mecca begins. On this day the windows of the houses may be
opened and the women (veiled) may appear and be seen at the windows.

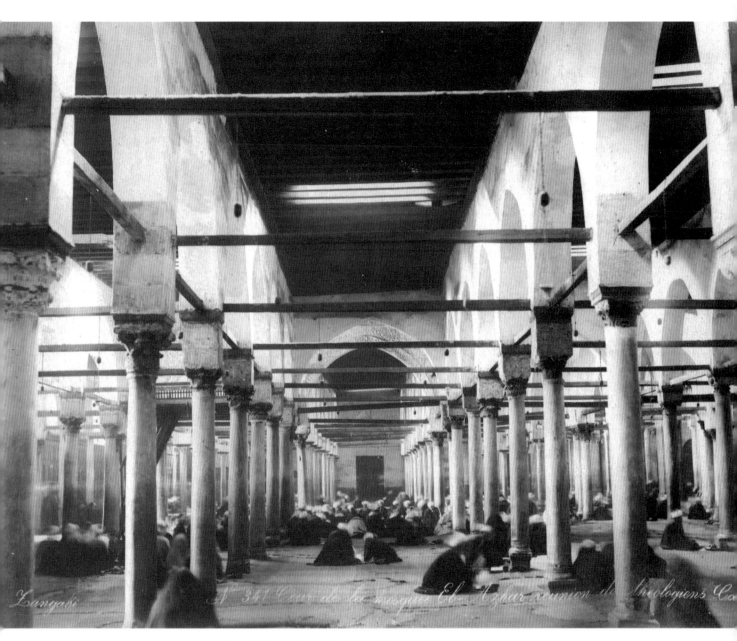

129. Zangaki. No. 341. Court of the Mosque El-Azhar, Cairo. c. 1875.
Reunion of the Theologians. For many this is the most famous mosque in the world, for it
is also the oldest university, founded in 973. At that time there were 10,000 students and
230 professors. In this photograph of the sanctuary those nearest the camera are praying
but in the background are groups of students listening to their teacher or professor. The
sanctuary is huge, with 390 columns.

130. *Colonel St Leger. Holy Carpet returns from Mecca, Cairo Citadel. 1883.* This amateur snapshot does not actually show the return of the Holy Carpet – or rather the covering of the Kaaba – but does demonstrate the solemnity of the ceremony. On the right two officers on horseback are waiting at the end of a long processional route lined with white uniformed soldiers. Behind them are the carriages of dignitaries and women. In the middle distance are several rows of troops and further away a square of troops.

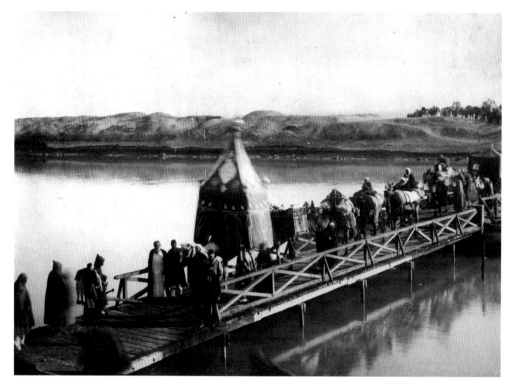

131. *AZ (Adelphoi Zangaki). No. 182. The Return of the Carpet from Mecca. c. 1890.* Every Muslim has the duty of making the pilgrimage to Mecca at least once in their lifetime. Many make theirs at the same time as the Mahmal, in or near October. The Mahmal is seen here crossing the Suez Canal by the floating bridge on its return journey from Mecca. It consists of the palanquin shown which represents the litter of Fatima, Queen of Egypt in 1250. At the time of the photograph the ceremonial departure was witnessed by huge crowds, many of whom will make the pilgrimage. The long procession includes the litters, covered of course, of women pilgrims.

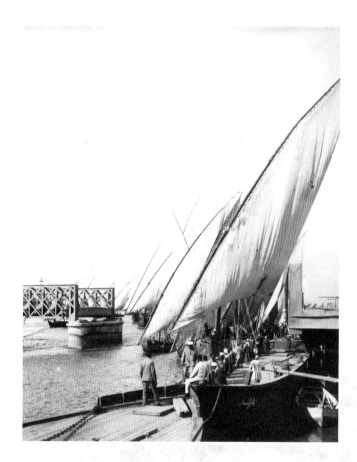

132. Bonfils. Sailing Boats Passing Through the New Bridge Over the Nile. Before 1900.
One section of the swing-bridge at Kasr el-Nil was opened at intervals and the elegant sailing boats queued up to pass through. As well as a sight for the town dwellers, it became a tourist attraction. It was the first bridge over the Nile and therefore of great commercial importance.

133. W. Hammerschmidt, Phot. No. 175. Boulaque, A Suburb of Cairo. c. 1865.
Bulaq is now absorbed into Cairo but was regarded in the nineteenth century as an independent suburb. Its main importance was as the commercial port of Cairo. Photographs of its waterfront are rare considering Boulaq's importance; this is a *carte de visite*. At one time the Egyptian Antiquities Museum was situated there.

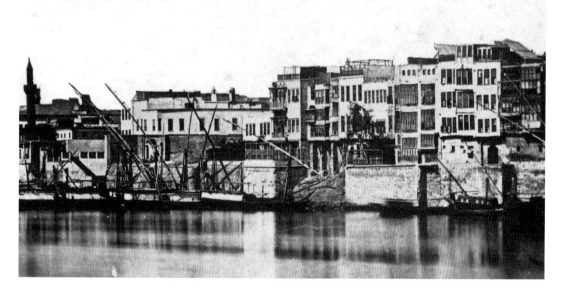

17. ALEXANDRIE – Ramleh station street

134. Alexandria. Station Street, Ramleh. Published Edition Artistique, P. Coustoulides, Alexandria, Egypt.
Lawrence Durrell (1922) wrote, "We are now in the heart of Ramleh ("Sand") the straggling suburb where the British and other foreigners reside. Lovely private gardens, the best in Egypt. Left of the station is Stanley Bay, a fine bit of coast scenery and a favourite bathing place."

135. Zangaki. No. 458. Commercial Street in Port Said. c. 1880.
The contrast between this and the streets of Cairo is obvious. Even the lattice screens are functional rather than decorative like *mashrabiya*. Nowhere is the difference more marked than in the clothes: Western-style suits with Turkish fez; the bowler hats and straw hats, even on the little girl, and soft felt hats. Only one Arab cap can be seen. All the street signs in this and similar pictures are not in Arabic but in English or French.

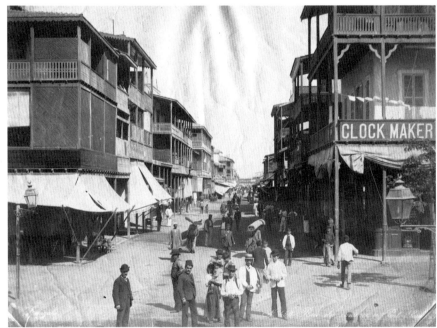

CLOCK MAKER

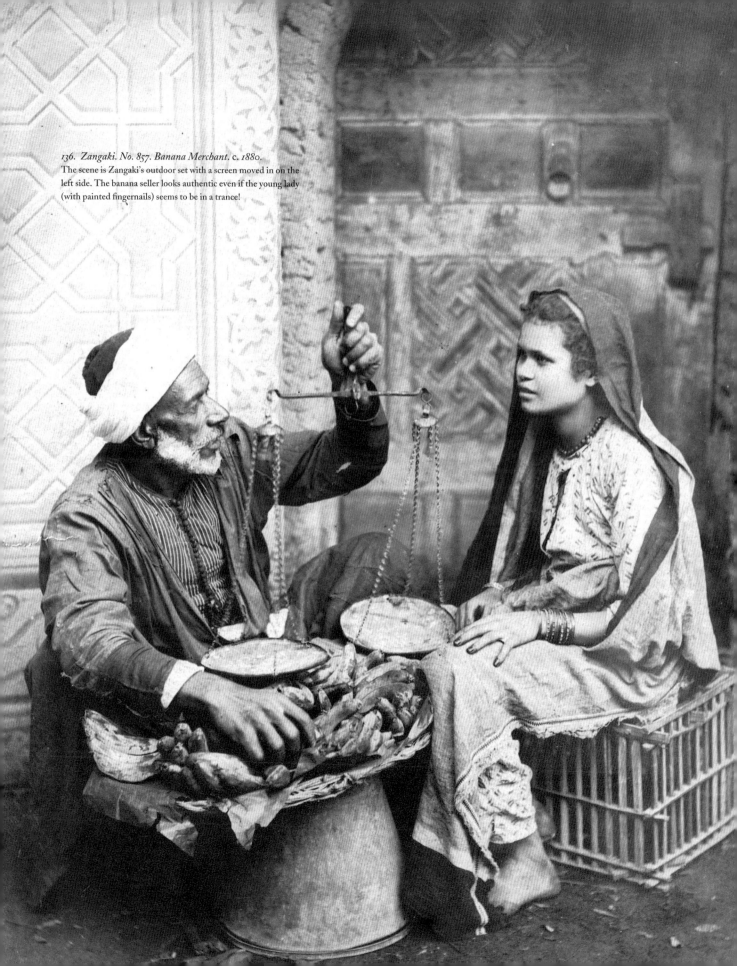

136. *Zangaki. No. 857. Banana Merchant.* c. 1880.
The scene is Zangaki's outdoor set with a screen moved in on the
left side. The banana seller looks authentic even if the young lady
(with painted fingernails) seems to be in a trance!

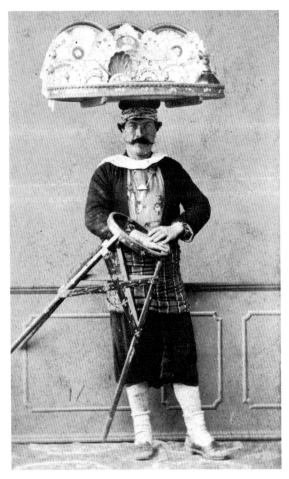

137. P. Sebah. Pedlar of China. c. 1865. *138. P. Sebah. Turkish Woman at Home. c. 1865.*

Photography had what were in effect three explosions of popular iconography, the final one being the advent of the postcard during the Edwardian era. Around 860 million cards were posted in the year 1908-9 in Britain alone and this figure does not include those cards bought to keep as souvenirs or place in albums. The first explosion was of stereocards, at their peak in the 1860s. It was reckoned that 5 million different views had been published and that each sold an average of 500 copies, making an awesome total of 2,500 million. These figures, albeit estimated, show that in an age before photographically illustrated magazines existed the quantities were gigantic. The stereocard required a viewer but the carte-de-visite, the second explosion, could be collected and put in an album with family pictures. The boom years were roughly the same as the stereocard years. At the height of "cartomania", 1861–7, it was estimated that in Britain alone up to 400 million cartes-de-visite were sold every year. Those of Sebah's were part of this trade and are contained in an album owned by a family in Leeds. They may have been made in Constantinople, but, because of their appeal, were just as easily sold in Cairo, Beirut or Tangiers.

139. P. Sebah. Pedlar of Simits (bread). c. 1865.

140. The back of figure 139.

141. Arnoux. No. 1149 (also Hte Arnoux 414). Untitled. c. 1885.
Hippolyte Arnoux specialized in pictures of street traders. This one of the young bootblacks
is a particularly good example. Each face is a portrait of a very streetwise youngster.

Right
142. Bonfils. No. 66. Saïs, Runners of Cairo. c. 1860.
The *saïs* (stableman) was given a rather splendid uniform and a long stick. He was
employed by important people not only to manage the stables but also to run ahead
of the coaches and clear the way by shouting a distinctive call, or if necessary by
using the stick. He also ran messages and was highly regarded in the household.

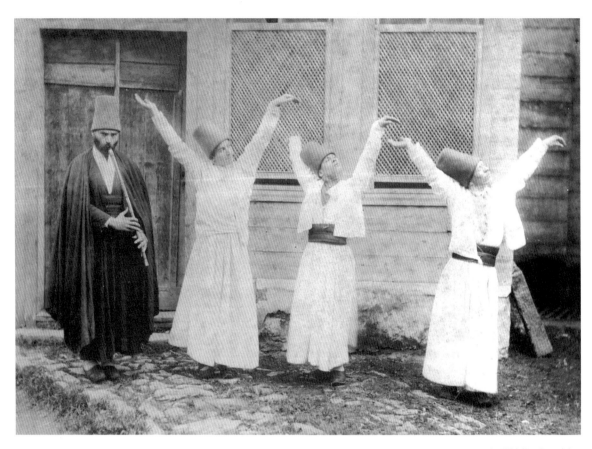

143. M. Iranian. No. 147. Dance of the Whirling Dervishes.
The performance (*zikr*, the invocation of the Divine Name) given by whirling
dervishes always amazed and amused the European visitors, who rarely
comprehended its religious significance. There are many different whirling sects
and also howling dervishes. The *zikr* was usually performed at each sect's
monastery where non-Muslims were welcome to attend. Every commercial
photographer had a picture of the whirling dervishes in his portfolio. They are all
similar except for this one, which was not taken in a studio but in a courtyard which
could be in their monastery. The music here is played on a *nay* or bamboo flute.

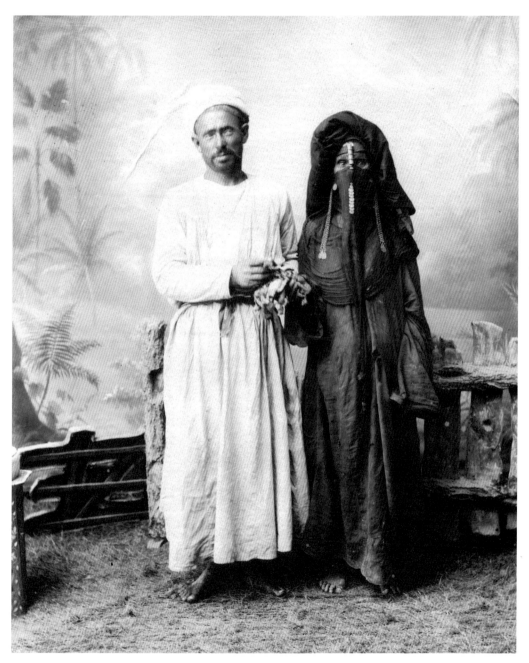

144. H. Arnoux, Port Said No. 1369. Seller of Game-birds from Tantah. c. *1880.*
Tantah was then an important town in the Delta, shortly to become a centre for the
expanding cotton export trade. The inappropriate background cannot conceal the
authenticity of the two people. The woman wearing the fancy veil is obviously terrified,
while the man is more relaxed. Both are holding what appear to be trapped wild birds.

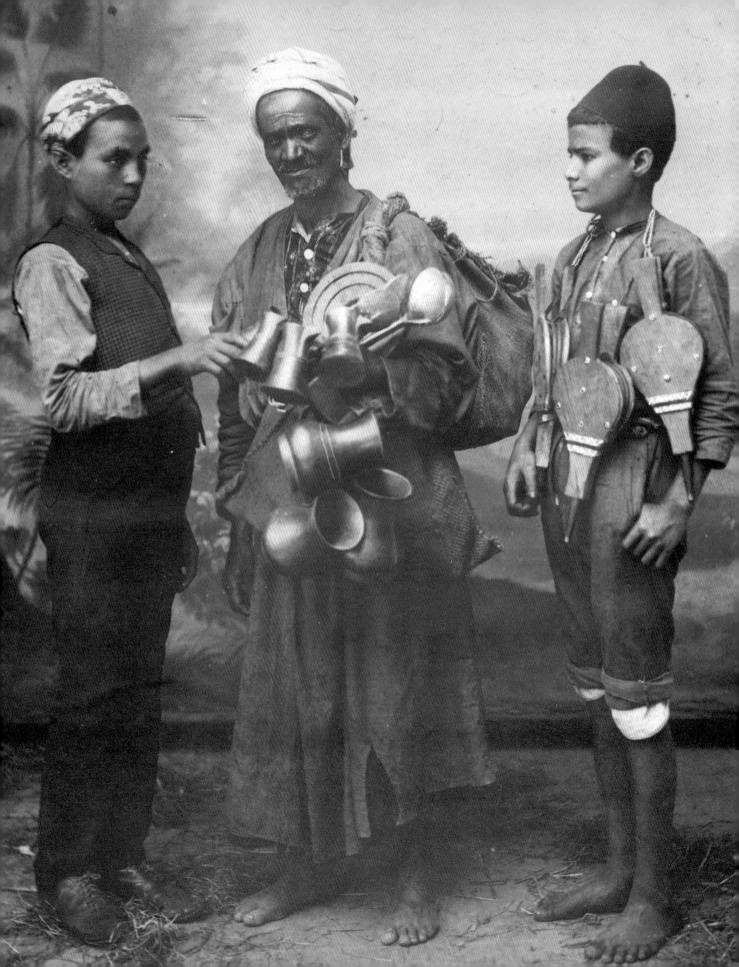

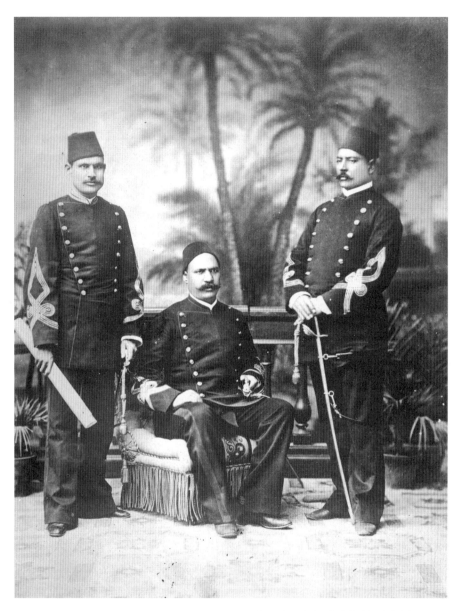

146. Anon. (Bonfils Studio.) Turkish Officials. c. *1870.*
Real power in Egypt was exercised by, in turn, the family of the
Albanian Muhammad Ali, followed by the French and then the
English. The suzerainty of Turkey was accepted in theory; its
visible aspect was in the uniforms of its many officials and
particularly the Turkish fez.

Left

145. Arnoux. Street Traders. c. *1875.*
The painted backdrop does not reach the floor and the
studio boards are barely covered with grass and twigs, yet
these are probably genuine tradesmen brought into the
studio. Possibly the young bellows seller accompanied the
old man who has what seem to be pots and pans. The
young customer (with shoes on) looks less genuine.

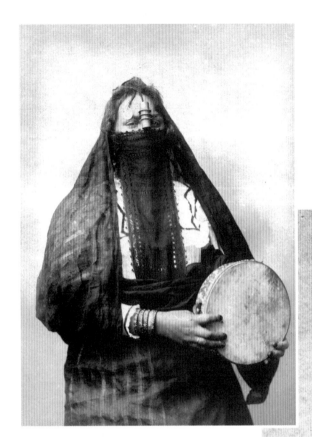

147. Zangaki. Arab Woman with her Tambourine. c. *1870.*
Lady Lucie Duff Gordon 13 January 1864: "After dinner the
French Consul sent to invite me to a fantasia at his house . . . I
was glad to see the dancing girls [but] at first I thought the
dancing queer and dull . . . But they called out to one Latifeh, an
ugly, clumsy-looking wench to show the Sitt [lady, i.e. Lucie]
what she could do. And then it was all revealed to me. The ugly
girl started on her feet and became the 'Serpent of the Nile'."

148. Zangaki. No. 242.
Arab Woman Carrying her Child. c. *1870.*
This image or variants of it went on to have an
extraordinarily long life as a postcard. One modern
writer, Sarah Graham-Brown (in *Images of Women*) finds
such photographs as stressing "the mystery of the veiled
women, contrasted with the sensual nakedness of the
child". She also adds, "the iconography of the Madonna
and Child was seldom far from the minds of artists and
photographers portraying women and children in the
Middle East". I prefer to think that the picture is typical
of everyday life with no subliminal message. Its
popularity stems from the contrast to European eyes of
over-clothed and under-clothed with hints of infant and
native innocence rather than sensuality.

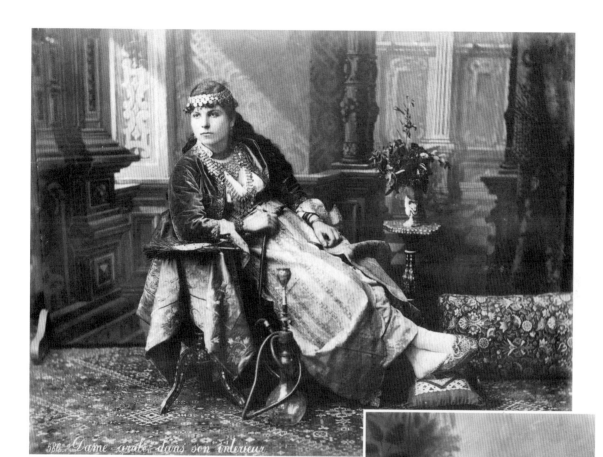

149. Bonfils. No. 586.
Arab Woman in her Room. c. 1870.
Unfortunately the stately French home is only
painted on a screen and the stand supporting it at
one end is visible. The standard props include the
narghile, the "hubble bubble" water pipe. The
picture is aimed at the tourist trade and the only
doubt is whether she is a genuine native woman
or a tourist dressed for the part.

150. Zangaki. No. 841. *Turkish Woman Making her Toilette.* c. 1880.
A fantasy for European travellers. Zangaki seems to have used every studio
prop he possessed and piled it up in front of the painted background. It
would have been impossible for her to use the mirror at that angle. While
the picture may be silly, it does display her garments extremely well.
Whether the girl was Turkish or not she was photographed, for the tourist
market, in Zangaki's Port Said studio.

151. Zangaki. c. *1880.*
The inappropriate background looking like a bad copy of the Bonfils château distracts from the reality of the performers. The attentive Nubian drummer makes us concentrate on the dancer who is a far cry from the show-business image of the oriental dancer.

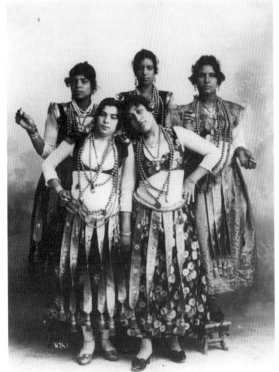

152. Anon. (Arnoux numbering). No. 360. Untitled. c. *1880.*
The girls appear to be a professional troupe of singers and certainly not wearing studio garments. The painted background, fortunately almost invisible, is of a French country park.

End of an Era

IN THE 1890s THE BIG prints had begun to disappear. One interesting late arrival was the PZ print. This was the product of the printers Photoglob, Zurich, who took over the negatives of several photographers.[1] With the aid of multiple printing they produced images of a delicate, accurate colour. This was unobtainable elsewhere, as photography in colour was virtually non-existent. These were to be the last big prints on the market, because in 1894 changes in postal regulations allowed the mailing of pictures on postcards. When, in 1897, the back of the card was divided into two parts for message and address, as it is today, there was a boom in the sending of postcards. The size of the boom can only be estimated. In 1910, 866 million cards were posted in Britain alone and millions more, unposted, were put into albums. High-quality colour printing was also used for postcards, many of which were printed in Saxony, which led the world in postcard printing.

One such scene has a history that can be traced. It appears in an album dated 1870, is called "The Arab School" and is signed Zangaki in the negative, numbered and with a caption in French. It proved to be a popular image and appeared in many albums. In the 1890s the print becomes slightly smaller with Zangaki's signature cut off.

It seems that the original negative may have been lost or destroyed, as this print is made from a copy negative of an earlier print whose edges were cracked. By the 1900s it has been transformed into a sepia postcard. Its final appearance, about 1910, is as a coloured postcard, excellently reproduced (see over).

For a photograph purporting to be a contemporary street scene to remain on sale for forty years is extraordinary, but other images in the same outdoor setting have also survived as coloured postcards. The woman selling oranges (figure 165) reappears selling mandarins and yet again selling tangerines, identical photographs captioned by bemused printers guessing at the type of fruit. Inaccuracies such as these are of no consequence providing the spirit of the picture is true. The orientalist paintings of Jean-Léon Gérome were not records of actual incidents but an imaginative re-creation. The Arab School photograph, although posed, illustrates a way of learning, boys listening to a traditional teacher, and conveys some sense of reality.

The invention of the box camera in 1900 brought about a significant change during the first decade of the century. Amateurs had been the first to dominate photography in Egypt. Even after the

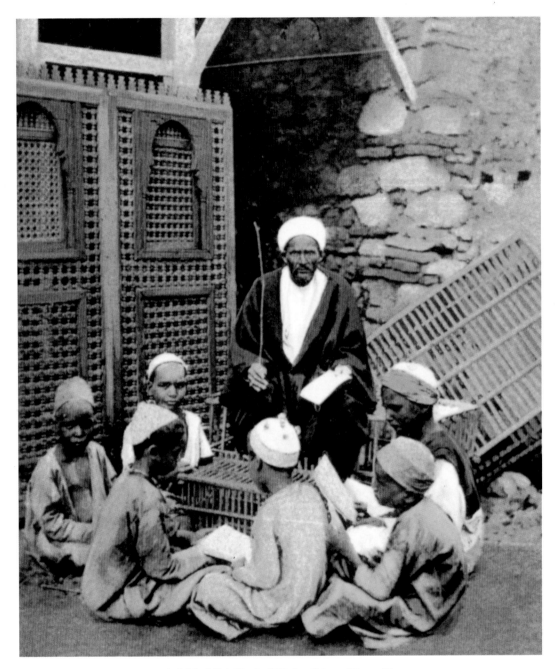

153. Arab School. Pub. Vegnios & Zachos, Cairo and Luxor. No. 1117.
One of the most enduring of all Egyptian images. It originally appeared before 1870 as a
large sepia print signed by Zangaki. Forty years later it became this coloured postcard.

arrival of the professionals they had continued to take photographs using similar equipment and with comparable skills. Kodak's Box Brownie inaugurated a new era in photography. It was for everyone to simply "Point and Shoot", so that of necessity photography came down to earth. The family snapshot replaced the staged romantic-orientalist photograph, and even though romance did continue to cling to the postcard, it was as a collectable souvenir rather than a postal item.

The postcard boom was not to survive the First World War. Saxony became enemy territory and the printing of Egyptian postcards was now concentrated in Britain. The "Real Photograph" postcard went into competition with the snapshot. It was the end of an era.

NOTE
1 The Photochrome process was invented in Zurich about 1887. See R. M. Burch, *Colour Printing and Colour Prints* (London, Sir Isaac Pitman and Sons Ltd., 1910. Reprinted Edinburgh, Paul Harris Publishing, 1983).

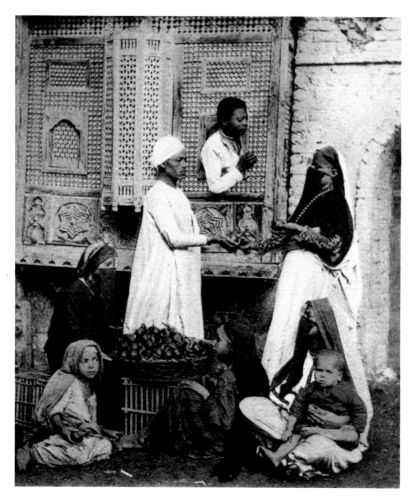

154. Cairo, Seller of Oranges, pub. Vegnios & Zachos, Cairo and Luxor. No. 405.
Scenes of native life were always popular even when staged in studios. This background had been in use for a couple of decades and links these publishers with Zangaki. The merchandise is more like figs than oranges, indicating that the caption writer took the title from another postcard of another fruit seller.

155. *PZ No. 15133. Mohamadens in Prayer. After 1887.*
Since the camera would usually be forbidden inside a mosque, an elaborate backdrop has
been devised to include even the distant view of the *mimbar*. Note the delicacy achieved in
the backdrop. The colouring was added later at the printers – PZ were not the photographers
and similar sepia originals were made by Zangaki, perhaps fifteen years earlier.

Right

156. *PZ 15123. Mussulman Women in their Town Costumes. After 1887.*
Mostly they were called Muslim women. Similar costumes were said to come
from Jerusalem; here they are Syrians from Beirut. This picture originally
appeared (*c.* 1880) in sepia, credited to Bonfils. Whatever its true origin, it was
extremely popular and widely available in Cairo and Alexandria.

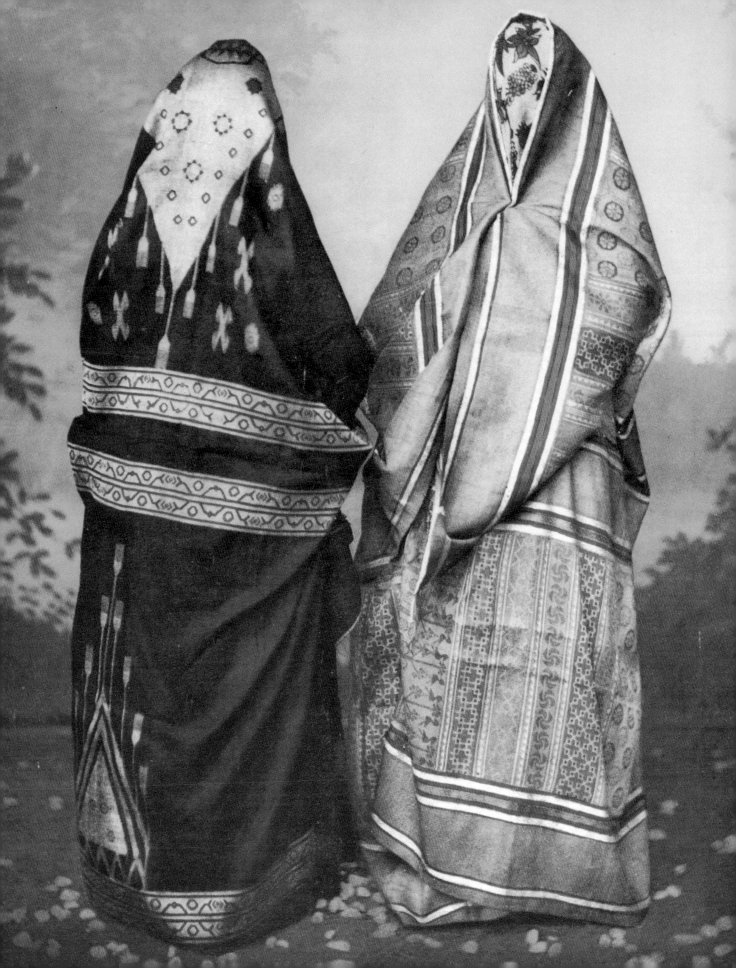

157. *PZ (Photoglob) 2123. Sagoutiers au Jardin Esbekieh,*
Kairo [Sago Palms, Ezbekieh Gardens, Cairo]. c. 1890.

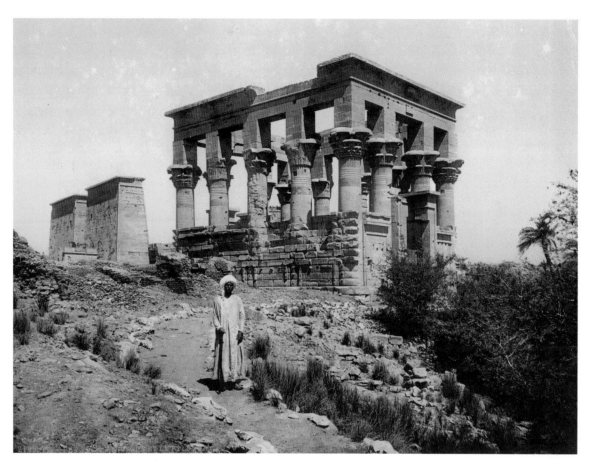

*158. PZ (Photoglob) 2199. Le Kiosque et Le
Pylon, Phylae (Pharaoh's Bed, Philae). c. 1890.*

159. PZ No. 15124. Camel Drivers Halting in the Desert.
Even if the camel drivers were posed for this scene, it does convey a sense of
reality which must have attracted tourists to purchase it.

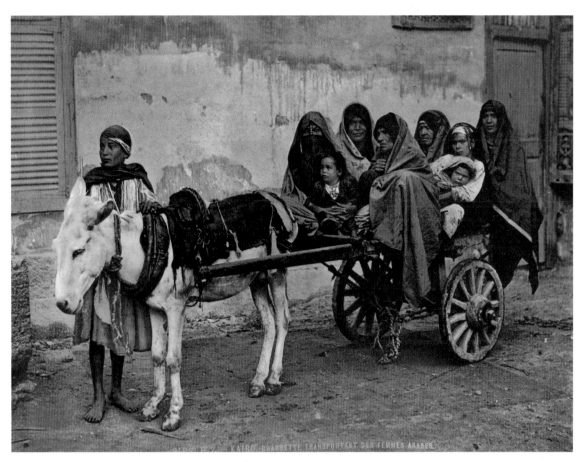

160. PZ 2187. Cart Carrying Arab Women. After 1887.
The Photochrom publishers coloured work of many different photographers
whose sepia originals can often be traced. The glimpse of the *mashrabiya* in the
corner implies from its style that this was Zangaki's outdoor studio.

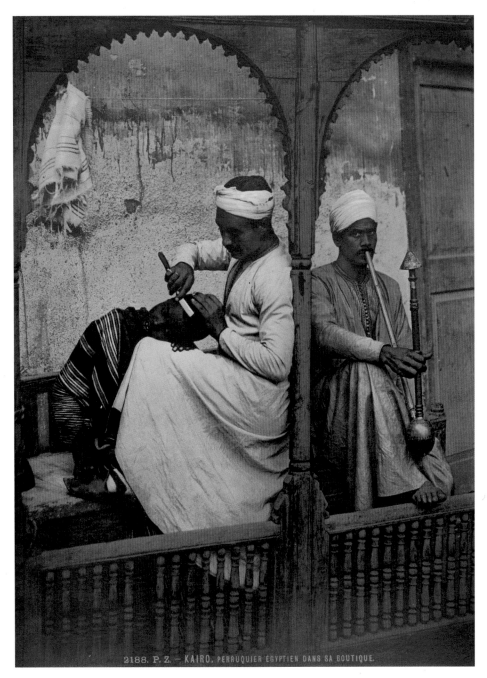

161. PZ 2188. Egyptian Barber in his Shop. After 1887.
The scene, even if not taken in a studio, is obviously staged and it is not clear if the young
lad is having his head shaved or not. The man on the right is smoking a *narghile* of
untypical design which suggests that it is authentic and not a studio prop.

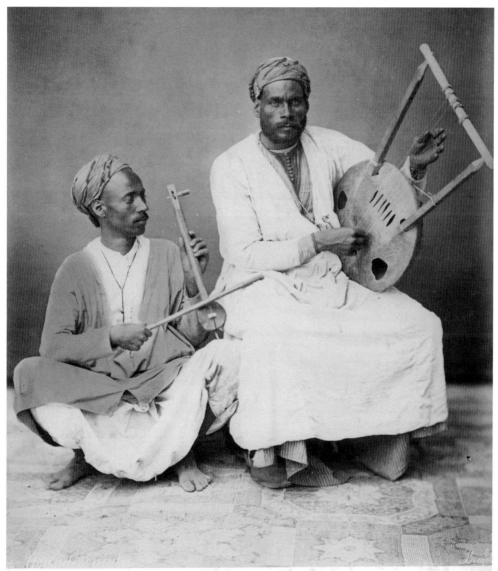

Egyptian Musicians

162. Bonfils. No. 610. Egyptian Musicians. c. *1880.*
The instrument on the left is the popular "spike fiddle", *kabak kemanje*, so called because
of the spike coming out of the sound box which was often no more than skin over a
coconut shell. The instrument on the right is the Egyptian lyre, the design of which goes
back to the tomb paintings. This photograph is hand-coloured.

163. Port Said, Rue du Commerce. Published Lichtenstern and Harari, Cairo.
No. 112. Not dated but c. *1905.*
The advertisements include Hotel Continental, Thomas Cook, Shepheard's Hotel,
all in Cairo, Eastern Telegraph Company and James Slavick (?) Shiphandlers
and Navy Contractors.

ALEXANDRIE. *Le Mahmal (Tapis sacré) passant par le Quai*

164. Postcard. Alexandria, The Mahmal (Sacred Carpet) Passes along the Quay.
Published Emil Pinkau, Soc. An., Leipzig. L.S. No. 66.
The Mahmal was actually the richly decorated camel litter, containing nothing but a
Quran, which accompanied the caravan which brought the covering of the Kaaba to
Mecca. It is to be seen just right of centre among the huge crowd – coloured green by
the artist although it should be red!

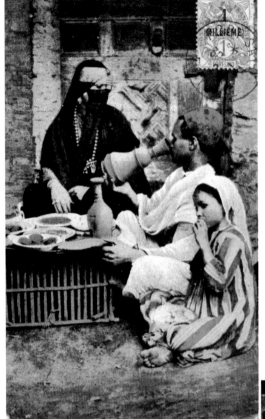

*165. Egypt. Arab Family. Published C. Andreopoulos,
Port Said, No. 71.*
The style of the postcard is more Cairo than Port Said so it is possible the original was by a Cairo publisher like Vegnios & Zachos who printed them with the name of the local shopowner, Andreopoulos. Added interest philatelically is the stamp, which says Poste Française, Port Said, although the port was not French territory. It is stuck on the front of the card, in keeping with the official postal regulations in French colonies from 1904 until the end of the Great War.

*166. Native Coffee House. Published Lichtenstern and Harari, Cairo.
No. 67. Posted 9 March 1907.*
The early travellers had shown either indifference or hostility to, or contempt for, the local populace. It was only with the growth of mass tourism and the improvements in photographic equipment that a scene like this, so typical of native life, was thought worth recording. Of the earlier photographers Sebah was virtually the only exception in picturing Egyptian life.

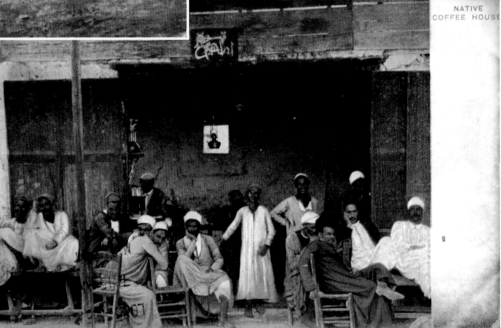

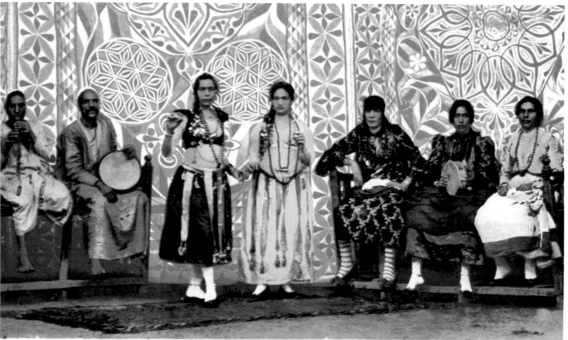

Danse arabe.

167. Postcard. Danse Arabe. Published by Purger & Co. München. Photochromiekarte No. 2512.
Exactly the same card was published by Lichtenstern and Harari, Cairo, as No. 28, except theirs
was described as a belly dance and the women wore filmy white blouses painted in by an artist,
and there was no carpet.

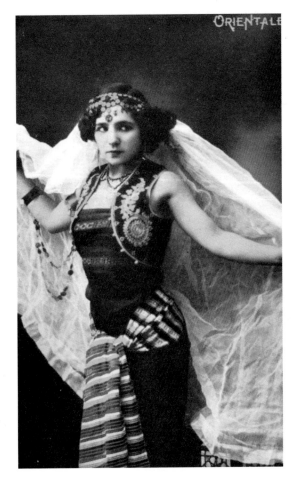

168. Orientale. Published by Cliché L. Papazoglou & Co., Egypte.
Example of one of the most popular types of postcard. Not quite so naughty as the "Danse au Ventre" but exotic enough to be a trophy for the postcard album. Not for posting home to grandmother.

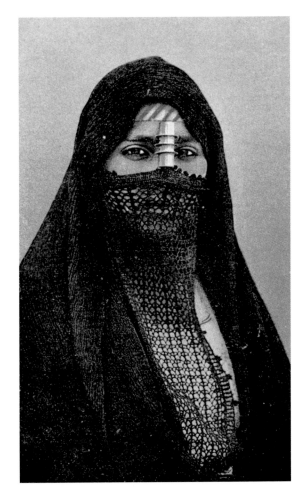

169. Cairo Native Woman. No. 2062. Published by Lehnert & Landrock, Cairo.
German publishers based in Tunis before the Great War and relocated to Cairo after the war. Their landscape pictures were regularly updated but their speciality was the picturesque image of the desert and of native women. The mesh of this veil is not strictly authentic but chosen to add mystery and glamour.

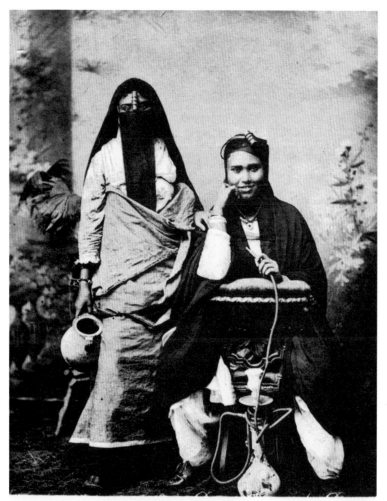

DEUX FEMMES DE DAMIETTE
DAMIETTA WOMEN

C. Zangaki Photographe. 1542

170. Two Women of Damietta. Published C. Zangaki Photographer, No. 1542.
One of the few direct links between the old large print photographers and the postcard
publishers. The studio background is the same as the one in the big prints by the Zangaki
Brothers; even the numbering may be the same. The mention of C. Zangaki only, rather
than of both brothers, suggests that C. was the dominant one of the two and it could be
he who appeared with the Zangaki Brothers van in earlier photographs. Alternatively it
might be a son of one of the brothers. Damietta, formerly an important city on one of the
mouths of the Nile, was superseded first by Alexandria and then by Port Said.

Right

172. Tancrede Dumas. Women with Water Pots. c. *1891.*
The clothing and the bare feet suggest these women are ordinary city dwellers for whom the ritual of the veil is softened by custom. The two in the background are fully veiled with the *burqu* but the picture has caught the moment when the woman in the centre realizes there was a man present and pulls the scarf across her face. The position of the height of the camera lens suggests that this was taken with the old-fashioned quarter-plate reflex camera.

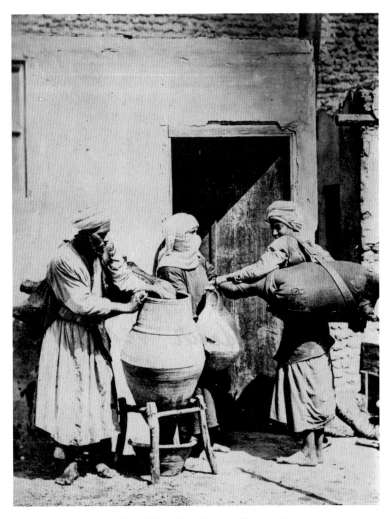

171. J. Pascal Sebah. Man Carrying Water. c. *1890.*
The arrival of the box camera at the turn of the century brought photography within the reach and competence of everyone, signalling the end of the era of the large tourist print. The earlier nineteenth-century amateur had to acquire the same knowledge as the professional by studying instruction manuals on the techniques of instantaneous photographs and the art of the unposed image. The box camera owner may not have obtained the quality but took similar views without the effort. This photograph of water-carriers at work illustrates the growth of a similar naturalistic photographic style.

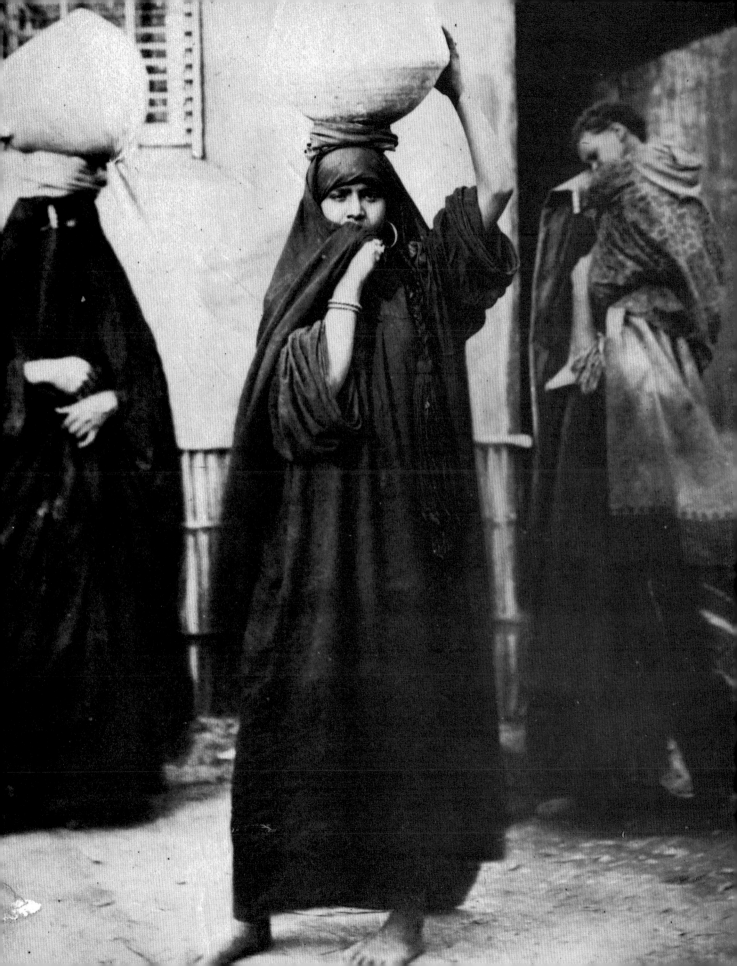

Photographers' Biographies

Abdullah Frères (Turkish)

The three Abdullah brothers were born in Constantinople from an Armenian family. Kevork, born 1839, completed his education in Venice. Vichen was a miniaturist painter working for the Sultans. With their third brother, Hovsep, they purchased the studio of Rabach in 1858. In 1867 they moved to the fashionable suburb of Pera. The studio dominated photography in Istanbul for 30 years until it was sold to Sebah and Jouillier in 1899. In 1863 they were appointed to the Turkish Court, subsequently being awarded eight Orders of Merit and three medallions from the Sultans. From about 1886 to 1895 they had a branch studio in Cairo but they found the climate unsuitable. William Allen lists their appearance in the Constantinople Year Books as follows: Abdullah Frères 1887, 1892, 1903, 1905 at 452 Grande Rue de Pera; Abdullah Frères Fils 1903, 1905 at 417 Grande Rue de Pera; Abdullah Fils (Léon) 1912, 1914 at Rue Bouyoukéré 21. Vichen became a Muslim shortly before he died in 1899. Hovsep died in 1902 still an Armenian. Kevork became a Catholic and died in 1918. The Abdullahs and Sebah were the most significant photographers in Constantinople and both for a while had studios in Cairo.

Hippolyte Arnoux (French)

The only dated Arnoux photograph is one showing the crowded waterfront at Port Said on 20 June 1885. Why this should be so is a mystery, unless it was to commemorate the withdrawal by ship of British troops from Khartoum via Suakim and the Red Sea. Arnoux's base was Port Said; his studio on the Place des Consuls was advertised as the "Photographie du Canal". He also had a boat

fitted out as a darkroom which possibly appears in some photographs. He photographed extensively on the canal, although he did not photograph the opening ceremonies as comprehensively as Sebah did. He produced an "Album du Canal" containing 24 prints. These are signed H. Arnoux with the distinctive curly letter H. Prints from this period are sometimes signed with just the initials HA or as H. Arnoux Port Said. One print has the usual negative mask but is also signed in ink "Hte Arnoux Port Said". The later studio prints have the far cruder signature "Arnoux" scratched into the negative, most distinctive as the letter N is reversed. These include many scenes of native types against French-style backdrops. If Arnoux started working in 1869 at the opening of the Suez Canal, the end is even less clear. It seems that his negatives passed into the hands of Georgiladakis as, for example, Arnoux No. 308 has a Georgiladakis overlay. This would be about 1895 when his partner Peredis was possibly acquiring the Zangaki negatives.

Antonio Beato, *c.* 1840–1905 (Italian)

Antonio said himself he was born on marshes in Italy; his older brother, Felice, said he was born in Venice. Both became British citizens before 1857. His sister married James Robertson of Constantinople and Felice became Robertson's partner. In March 1857 Antonio went with them to the Holy Land when the partnership became Robertson, Beato and Co. (the entries for Robertson and the Beatos in the Consular Register of British Subjects, Jerusalem, 1857 are reproduced in *The PhotoHistorian* No. 105, 1994). Felice continued on to India followed by Antonio in 1858. About 1860 Antonio returned to Cairo, possibly because of his health, as shortly afterwards he

moved to Luxor which was well-known for its healthy climate as well as for its antiquities. Luxor remained his base and home for the next 40 years. He photographed every excavation along the Upper Nile. On his death a substantial number of his negatives were purchased by the Cairo Museum as a permanent record of the antiquities.

Emile Béchard, active 1870s–90s (French)

Probably the son or younger brother of Henri Béchard. Henri's studio was in the Ezbekieh Gardens, Cairo, where he was active during the 1870s. Emile co-published, in Paris, a book of Henri's photogravures in 1887. In the 1890s Emile had a studio in the Ezbekiyeh Gardens, possibly the one Henri had before, and was in partnership with another Frenchman, H. Délié, about whom nothing is known. Isabelle Jammes describes Emile as a banker without giving any further information.

Henri Béchard, active 1870s–80s (French)

Awarded the Gold Medal at the Universale Exposition 1878. In 1887 Emile Béchard and A. Palmieri published Henri's photogravures in "L'Egypte et la Nubie". His studio was in the Ezbekiyeh Gardens, Cairo. Buckland and Vaczek reproduce in "Travellers in Ancient Lands", page 193, two almost identical street scenes, with and without a donkey, one signed H. Béchard and the other signed J. Pascal Sebah. The authors suggest that Béchard may have been the photographer. On the other hand, two photographs attributed to Béchard or Sebah by Frederico Peliti are clearly neither, as they were taken in Zangaki's outdoor studio.

Francis Bedford, 1816–94 (English)

Bedford was in turn an architect, a lithographer and a photographer specializing in church architecture. He was one of the first to start photographing, systematically, large views of the whole of England (George Washington Wilson began 1857, Francis Frith 1861). In 1862 Queen Victoria commanded him to accompany her son Edward, Prince of Wales, on his Middle East tour, together with Prince Alfred, whose interest in photography possibly influenced the Queen's decision. The tour began in Cairo on 3 March 1862 and was carefully documented. During the next four months Bedford made 210 wet collodion negatives. From these, 172 prints were exhibited at the German Gallery, New Bond Street, to considerable acclaim. These were sold on subscription in 21 parts of eight pictures at two guineas with a final part of 12 prints at three guineas, totalling 45 guineas for the complete portfolio – 48 views of Egypt, 76 of the Holy Land and Syria, 48 of Constantinople, the Mediterranean, Athens, etc. The 52-page catalogue included extensive notes on most of the pictures. A book of 48 prints in a smaller format with text by W. M. Thompson was issued in 1867.

Bonfils (French)

La Maison Bonfils was established in Beirut, Lebanon, in 1867. Head of the family was Félix Bonfils, 1831–85, who founded the firm with his wife, Marie-Lydie Cabanis Bonfils, 1837–1919. It is thought that Félix travelled to take views while Marie-Lydie took the studio portraits. When Félix died in 1885 their son Paul Félix Adrien Bonfils, 1861–1929, joined his mother in the business. In 1895 Adrien left to open a hotel at Broummana, near Beirut. After World War I

he left Lebanon for France. His mother continued the business until 1916 when she was evacuated by the United States Navy from Beirut to Cairo. Her assistant Abraham Guiragossian, a Palestinian, took over and ran the business until about 1932. He published a "Catalogue Général des Vues Photographiques de l'Orient". Confusingly Baedeker's Palestine and Syria 1894 says that the prints were being sold by Nicodemus in the Lebanon.

The Bonfils family (and assistants) were enormously prolific, producing 15,000 views and 9,000 stereos of Egypt, Syria, Greece and the Lebanon in four years. They had branches or depots in Cairo, Alexandria, Baalbeck and Jerusalem, but curiously not in Constantinople. Critics have pointed out that some of the native types were faked.

Émile Brugsch Pasha, 1842–1930 (German)

Egyptologist and brother of Pasha Heinrich Brugsch, Émile made many photographs of the exhibits in the Cairo Museum. He is famous for his photographs of the mummy of Rameses II. Baedeker's, Egypt 1898 states that prints could be obtained at the shop of Diemer.

H. Délié (French)

See Emile Béchard.

Maxime Du Camp, 1822–94 (French)

The photographic fame of Du Camp rests almost entirely on one magnificent book, *Egypte, Nubie, Palestine et Syrie* (1852), the first important French book to be illustrated with photographs. Blanquart-Evrard made the plates for the 125 illustrations. It sold for 500 gold francs and was a great success. Du Camp became an officer of the Légion d'Honneur, much to the amusement of his travelling companion Gustave Flaubert who had written racily of his own adventures.

On the return journey Du Camp sold his photographic equipment in Beirut and never photographed again. He founded a literary magazine which published Flaubert's *Madame Bovary*. He wrote of his adventures as a volunteer with Garibaldi. His *Souvenirs Littéraires* was said by other Egyptologists to include "many bitter and grossly false statements" about his contemporaries, most notably Mariette Bey Pasha, the French founder of the Egyptian Antiquities Service.

Tancrede R. Dumas, d. 1905 (French)

Dumas opened a studio in Beirut in the 1860s but was always overshadowed by the Bonfils family. He opened another studio in Constantinople in 1866 and travelled to Rhodes, Cyprus and Egypt producing four volumes of photographs. He was official photographer to the American Palestine Exploration Society, who between 1871 and 1879 were surveying the east side of the Jordan. The survey, published in 1876, included 99 of his photographs. He may have had a link with Zangaki because the photograph on p. 120 also appears credited to him, although the background is clearly Zangaki.

Francis Frith, 1822–98 (English)

By far the most successful and prosperous of all the photographers of Egypt. His father, a Quaker, was a cooper in Chesterfield, but probably much more than a humble artisan. After serving an apprenticeship, Frith worked for five years in a factory until he suffered a nervous breakdown. His parents, on doctor's orders, took him on a two-year tour of Britain. In 1845 he moved to Liverpool where he ran, in partnership, a prosperous wholesale grocery business. Tiring of this after five years, he sold up and started an even more prosperous printing business. In 1853 he took up photography and in 1856 sold the printing firm. At 34 years of age he was a gentleman of leisure with ample means.

In September 1856 he made his first trip to Egypt and Nubia and the Holy Land, returning in July 1857. His equipment included one extra large and one stereo camera. His companion was Francis Wenham, optical adviser to Negretti and Zambra, who eventually published Frith's stereo photographs. Frith signed and dated many of the early prints, but on those where the name Frith is only printed underneath it could mean they were taken by Frank Mason Good. On his second tour, from November 1857 to May 1858, he again visited the Holy Land, Syria and the Lebanon.

Obscurity surrounds his third and final trip to the Middle East and it is difficult to pinpoint the results as the photographs are not dated like the earlier ones. It is usually said the trip was in the summer of 1859. This is unlikely, as any experienced traveller to Egypt and Nubia would have known that the heat would be intolerable. He could have left late in the summer and worked through the winter, as he married soon after his return. The marriage to Mary Ann Rosling, daughter of a noted photographer, was on 17 July 1860 and in June 1860 he had given a talk to the Photographic Society of Liverpool. This suggests that his return was in May 1860, the same month as his previous trip. After his marriage he began his monumental work of photographing every town and village in Britain, which still survives today.

A. Gaddis and Son (nationality unknown)

Antonio Beato had assistants working for him and the shadow of one in a fez appears in a Beato photograph with Beato at the camera. His name is not known. After Beato died in 1905 his widow tried to sell the premises. In 1907 A. Gaddis Senior started trading from what seem to be the same premises. In 1987 when I examined prints in the shop I found they were stylistically similar to Beato's. The business was then owned by A. Gaddis Junior.

Georgiladakis, active 1880s–90s (Greek?)

No biographical information. For a brief period he was in partnership with Peredis. Possibly at one time an assistant to Arnoux. He is an interesting photographer in his own right.

Frank Mason Good, 1839–1928 (English)

Born in Deal, Kent. Trained by his father as a druggist and chemist. From 1866–77 in London listed as Photographic Chemicals Manufacturer. Died forgotten in Hampshire. It has been suggested that he was an assistant to Francis Frith but he travelled independently and later sold his prints to the Frith publishing company. Bertrand Lazard has disentangled Good's four Middle East trips: 1866–7 Egypt and Holy Land, published Frith 1876; 1868–9 Egypt and Nubia, published Mansell; 1871–2 Egypt, Constantinople and Malta, published Frith; 1875 Holy Land, published Mansell and by Good himself. Lantern slides were also published by the Woodbury Publishing Company.

W. Hammerschmidt (German)

Began work in Berlin and was awarded a medal in the Berlin Exposition 1863. From 1861 onwards he exhibited with the Société Française. He had a studio in Cairo and over the years exhibited a range of sound, well-made views both of antiquities and street scenes. Many of his images were used by PZ and probably by postcard makers. He was shot and wounded while photographing pilgrims to Mecca. He returned to Berlin where it is said he continued to maintain a studio in his later life.

M. Iranian (nationality unknown)

One of the ghostly figures of Middle East photography about whom little is known for certain. In 1892 he is on record as having a studio at Impasse Ottoni 7, Constantinople. The similarity in the writing of his captions to

those of the Abdullah Brothers suggests that he was employed by them as an assistant and caption writer, and when the Abdullah company declined he set up on his own. There are many others who started their photographic life by being trained by the Abdullahs.

Colonel Henry Hungerford St Leger DSO, 1833–1925 (Scottish)

A career army officer who served with the Cameron Highlanders in the Egyptian Campaign of 1882, the Nile Expedition 1884–5, and was Commandant of the Sudan Frontier Field Force, based on Fort Kosheh, 1885–6. He owned two cameras and photographed during the campaigns, particularly the Nile Expedition. Korosko, the ancient staging post for the camel trains going south, was just below the Second Cataract and the farthest point the Nile steamers reached. In 1881 and 1883 there were uprisings in the Sudan by the Mahdi and Osman Digna, which led to the siege of Khartoum and the death of General Gordon. The relief force under the command of Lord Wolseley originally planned to sail up the Nile to Korosko and then travel overland by camel. The photographs show the camp at Korosko, the assembling of the camels and the actual scene of the abandonment of the campaign.

Lehnert & Landrock (German)

Although primarily postcard producers, they also made high-quality large prints in sepia gravure. Before World War I they were based in Tunis and during the war returned to Germany. After the war they resettled in Cairo, founding a prosperous business which is still in existence today. They were active photographers unlike most other postcard manufacturers. They sold extensive series of "real photographs" of the antiquities as well as a popular gravure series of exotic women and romantic desert scenes.

G. Lekegian and Co. (nationality unknown)

There are lots of Lekegian prints in circulation which are all very well made, although Lekegian himself is a mystery. All his prints are labelled in two languages, the English "and Co.", the French "Photographie Artistique". To add to the confusion, his cabinet cards were printed in Vienna. His studio was near Shepheard's Hotel (which he always spelled incorrectly) in the Ezbekieh Gardens. His later cards state "Photographers to the British Army of Occupation" but no photographs have been traced to the campaigns of 1882–5, so this may relate to the Kitchener Campaign of 1898. There is a cabinet portrait dated 6 April 1890, a picture of the 21st Lancers in Cairo dated 1899 and a book *Celebrities of the Army* using photographs dated 1899 and 1900. The book *New Egypt*, published in 1906, says "he has besides some remarkable portraits, a unique collection of views and native types both in large prints and in postcards". I have never seen any postcards, but the existing dates do suggest he was a late arrival on the photographic scene. A back of a cabinet card says he was awarded a medal for "water printing" at an exhibition by the Gilman Art Gallery but no date is given nor any explanation of "water printing".

Robert Murray, 1822–93 (Scottish)

Born in Edinburgh. Apprenticed, aged 18, to Millwall shipyard where his brother was manager for the Fairbairn company. Travelled to Malta "and elsewhere" for Fairbairn. When Fairbairn moved from Millwall back to Manchester he went to Russia for Messrs Blyth. From 1851 he was in Malta and Egypt as Chief Engineer to the Viceroy of Egypt. He taught himself photography on the banks of the Nile from a shilling handbook. Joseph Bonomi, an Egyptologist, wrote the text for the 46-page booklet accompanying his portfolio of 163 prints of Egypt, Nubia and Malta, published by J.

Hogarth, Haymarket, London 1856. Some of the prints were exhibited in Edinburgh and Birmingham. In 1857 the portfolio was very favourably reviewed in *The Athenaeum*. Francis Wenham had designed a steam yacht for Francis Frith's first trip. This was sold to the ruler of Egypt on the advice of the Pasha's "Scottish Engineer". In 1861 he is described as Engineer Surveyor to the Board of Trade and in 1862 Hogarth published a portfolio of his Normandy prints. The same year he joined the Amateur Photographic Association, his membership (no. 291) sometimes being the only clue to a print's origin. In 1873 he was living in Edinburgh and giving talks to the Edinburgh Photographic Society. In 1882 he presented an album of "Scotch Views" to Queen Victoria. In 1890 he was Principal Officer to the Board of Trade for the South and South-West Coast of England. He died in retirement at Sidcup, Kent, in 1893.

Peredis, active 1890s (Greek?)

No biographical information. At one time in partnership with Georgiladakis, possibly another Greek. Both names appear on partnership prints with captions written by Georgiladakis whose style of writing K is distinctive. After the partnership collapsed the prints have one or the other of the names obliterated. The similarity of the studio backgrounds indicates a connection with Zangaki Brothers, where perhaps Peredis was an assistant. Georgiladakis shows similarities with Arnoux so it may be that the two Port Said assistants got together when their principals moved on.

PZ Photoglob Zurich (Swiss)

The PZ photographs are famous for their brilliant colouring. The process called Photochromy was developed in Zurich by Orell, Füssli and Co. in 1887. The English Photochrom Company was not formed until 1896 and produced vast quantities of postcards but no large photographs. The process is not colour photography, but rather the use of collotype photolithography with a solution of asphaltum of ether, and involves as many as sixteen printings of different colours. The PZ prints of Egypt were made from photographs or negatives of several photographers including Zangaki and Bonfils. There are sepia photographs captioned "Edit Photoglob" which could have been taken earlier than 1887. Exactly the same typography and numbering is used by the company Edit Schroeder & Cie, Zurich, who may be connected.

Pascal Sebah, active 1857–1908 (Levantine of French origin)

Born 1838? Opened his first studio in Constantinople in 1857 with a Frenchman, A. Laroche, as partner. Prepared 370-page book of Turkish costumes for the Vienna Exhibition of 1873. Studio opened in Cairo before 1875. Frenchman Policarpe Jouillier became a partner in 1884–5 and the name of the business became Sebah and Jouillier in 1888 until Jouillier returned to France about 1900. Sebah sold the business in 1908 but the name continued in Istanbul until 1950. There is a possibility that there were two Sebahs, Pascal and a son, J. P. Sebah. Prints signed "P. Sebah phot." can usually be dated before 1875. The signature J. P. Sebah was used in 1890–1 and, although Sebah and Jouillier existed as a partnership in 1884, the prints signed with both their names seem to be of a later date. This suggests another possibility – that the J in J. P. Sebah could refer to Jouillier. The Cairo studio closed by 1898 when Baedeker reported that Sebah prints were being sold by Heymann & Co.

John Shaw Smith, 1811–73 (English)

Born in London but spent his life on his Irish estate. His descendants have the manuscript diary kept by him and his wife Mary of an extended trip to Egypt, Nubia, Sinai and the Holy Land from December 1850 to July 1852. He took about 350 calotypes during this period and possibly no more than 100 in the rest of his life. He committed suicide in Dublin.

Dr C. G. Wheelhouse, active 1849–50 (English)

The only information on his photographs comes from the handwritten note in his album "Photographic Sketches from the Shores of the Mediterranean" now in the collection of the Royal Photographic Society. "These photographs were taken by me in the years 1849–1850 when in medical charge of a Yachting party consisting of Lord Lincoln, afterwards the Duke of Newcastle and War Minister (in 1854) during the Crimean War; his brother Lord Robert Clinton; Mr Egerton Harcourt; and Mr Granville Vernon of Grove Hall near Retford . . . On the completion of the tour these negatives were given to Lord Lincoln, and were all, unhappily, destroyed by a fire by which his Lordship's seat in the 'Dukeries' was nearly burned down in 1879 (March 26th)."

Zangaki (Cretan or Cypriot)

Their photographs are always signed just "Zangaki" with a curious Z that in the past has been mistaken for an L. One bowler-hatted brother appears in some pictures beside their darkroom van, on which their name appears in English and Arabic although their photographs are all captioned in French. The authors of the book on Frederico Peliti's collection draw attention to the discovery of a piece of pasteboard with "Adelphoi Zangaki" written in Greek suggesting they came from either Crete or Cyprus where the suffix "aki" is more common. There is an odd picture of Suakim, a politically dangerous location, signed just "AZ" (with the unmistakable Z) which could be an abbreviation of Adelphoi Zangaki, thereby confirming their Cretan or Cypriot origin. It has been suggested that their initials were C and G and there is a postcard from the mid-1890s captioned "C. Zangaki, Photographe, No. 1542". It is of two women of Damietta against a studio background of a Roman column and a balustrade, the same as that seen in the large early prints. Zangaki Brothers were noted not only for their views but also for depicting native life, so the original of this postcard may date back to the 1870s. Zangaki Brothers are said to have had a studio in Port Said but it seems that by the mid-1890s they may have sold out to Peredis, because several of his backgrounds are identical – for example Peredis no. 5 is the same as a Zangaki no. 15. A Zangaki Brothers photograph reappears as a postcard issued by the Comptoir Philatélique d'Egypte, Alexandria, in a style in vogue in 1904. A studio set, as in Plate 151, appears in signed photographs and is a close copy of the Bonfils studio, seen in Plate 149.

Bibliography

Allen, William, "Sixty-nine Istanbul Photographers 1887–1914", in Kathleen Collins (ed.), *Shadow and Substance. Essays in Honour of Heinz Henisch*, Pennsylvania, Amorphous Institute Press, 1990.

Badger, Gerry, and Goldhill, Judy, "Early Photography in Egypt", *Creative Camera*, 186, Dec. 1979.

Berger, Morroe, "The Belly Dancer", *Horizon*, Spring 1966 (American Heritage), VIII, 2.

Buckland, Gail, and Vaczek, Louis, *Travellers in Ancient Lands*, Boston, New York Graphic Soc., 1981.

Bull, Deborah, and Lorimer, Donald, *Up the Nile*, New York, Clarkson N. Potter, 1979.

Buonaventura, Wendy, *Serpent of the Nile: Women and Dance in the Arab World*, London, Saqi Books, 1989.

Chevedden, Paul, *The Photographic Heritage of the Middle East*, Malibu, Undena Publications, 1981.

Cizgen, Engin, *Photography in the Ottoman Empire 1839–1919*, Istanbul, Haset Kitabeve, 1987 (extensive bibliography including Turkish sources).

Cottrell, Leonard, *The Mountains of Pharaoh*, London, Robert Hale, London, 1956.

Darrah, William C., *The World of Stereographs*, Gettysburg, W. C. Darrah, 1977.

— *Cartes de Visite*, Gettysburg, W. C. Darrah, 1981.

Dawson, Warren, and Uphill, Eric, *Who Was Who in Egyptology*, 2nd edn, London, Egypt Exploration Society, 1972.

Flaubert, Gustave, *Flaubert in Egypt*, tr. Francis Steegmuller, Boston, Brown Atlantic-Little, 1979.

Forster, E. M., *Alexandria*. Introd. by Lawrence Durrell, London, Michael Haag, 1986. (1st edn 1922.)

Fouchet, Max-Pol, *Rescued Treasures of Egypt*, London, George Allen & Unwin, 1965.

Gavin, Carney, *The Image of the East*, University of Chicago Press, 1982 (about Maison Bonfils).

Gordon, Lady Lucie Duff, *Letters from Egypt*, London, R. Brimley Johnson, 1902, 3rd edn (1st edn 1869).

Graham-Brown, Sarah, *Images of Women: The Portrayal of Women in Photography of the Middle East 1860–1950*, London, Quartet Books, 1988.

Hershkowitz, Robert, *The British Photographer Abroad. The First Thirty Years*, London, Hershkowitz, 1980.

Howe, Katherine Stewart, and Wilson, Michael, *Excursions along the Nile*, Santa Barbara Museum of Art, 1993.

James, T. G. H. (ed.), *Excavating in Egypt. The Egypt Exploration Society 1882–1982*, London, British Museum Publications, 1982.

Jammes, Isabelle, "Louis-Désiré Blanquart-Evrard 1802–1872", *Camera*, Dec. 1978. Lucerne, C. J. Bucher.

Jammes, Marie-Thérèse, and André, "En Egypte au temps de Flaubert", Kodak Pathé, Paris, 1975. English trans. in *Aperture*, 78, 1977.

Jay, Bill, *Victorian Cameraman*, Newton Abbot, David and Charles, 1973 (about Francis Frith).

— "Francis Bedford 1816–1894", *Bulletin of the University of New Mexico*, 7, 1973.

— "Up the Nile with Francis Frith, Francis H. Wenham 1824–1908", *Northlight 7: Forgotten Victorians*, New Mexico, 1977.

Lazard, Bertrand, "Frank Mason Good", *The PhotoHistorian*, 93 and Supplement 93, Summer 1991 (about relationship between Good and Frith).

Miraglia, Marina, *et al.*, *Frederico Peliti: An Italian Photographer in the Time of Queen Victoria*, Manchester, Cornerhouse, 1994.

Monti, Nicolas, *Africa Then; Photographs 1840–1918*, London, Thames and Hudson, 1987.

148 *Egypt*

Naef, Weston, *Early Photographers in Egypt and the Holy Land*, New York, Metropolitan Museum, 1973.

Osman, Colin, "Robert Murray of Edinburgh (1822–1893). The Discovery of Neglected Calotypes of Egypt", *The Photo-Researcher* (the journal of the European Society for the History of Photography), 6, March 1997.

— "Antonio Beato Photographer of the Nile", *History of Photography Journal*, 14, 2, April–June 1990.

— "New Light on the Beato brothers", *British Journal of Photography*, 134, 6636, 16 Oct. 1987.

— "The Beato Brothers, an attempt at Nomenclature", *RPS Historical Group Quarterly*, 79, Winter 1987.

— "Pascal Sebah and Policarpe Jouillier", *The PhotoHistorian*, 115 and Supplement 115, Feb. 1997.

— "Photography and Tourism in Egypt", Article commissioned for New York Gallery, Unpub., 1984.

— "Postcards from Egypt", *RPS Historical Group Newsletter*, 64, Spring 1984 (about the Zangaki Brothers).

— "Black and White Postcards", *Creative Camera*, 226, 1983 (about racial stereotypes).

Perez, Nissan, *Focus East; Early Photography in the Near East 1839–1885*, New York, Abrams, 1988.

Pudney, John, *Suez, de Lesseps' Canal*, London, J. M. Dent, 1968.

Roberts, David, *From an Antique Land. Lithographs of Egypt and the Holy Land (1842–49). With comments from his unpublished journal*, London, Weidenfeld and Nicolson, 1989.

Romer, John and Elizabeth, *The Rape of Tutankhamun*, London, Michael O'Mara Books, 1993.

Said, Edward, *Orientalism*, London, Routledge & Kegan Paul, 1978.

— *Culture and Imperialism*, London, Chatto and Windus, 1993.

Taylor, Roger, "Discovering Identities", *The PhotoHistorian*, June 1997 (about Robert Murray).

Thomas, Ritchie, "Some 19th Century Photographers in Syria, Palestine and Egypt", *History of Photography Journal*, 3, 2, April 1979.

Van Haaften, Julie, *Egypt and the Holy Land in Historic Photographs*, New York, Dover Publications, 1980 (about Francis Frith).

— "Francis Frith and Negretti and Zambra", *History of Photography Journal*, 4, Jan. 1980.

Vercoutter, Jean, *L'Égypte à la chambre noire; Francis Frith, photographe de l'Égypte retrouvé*, Paris, Gallimard, 1992.

Wilson, Derek, *Francis Frith's Travels*, London, Dent, 1985.

Index